THE
WEDDING
DRESS

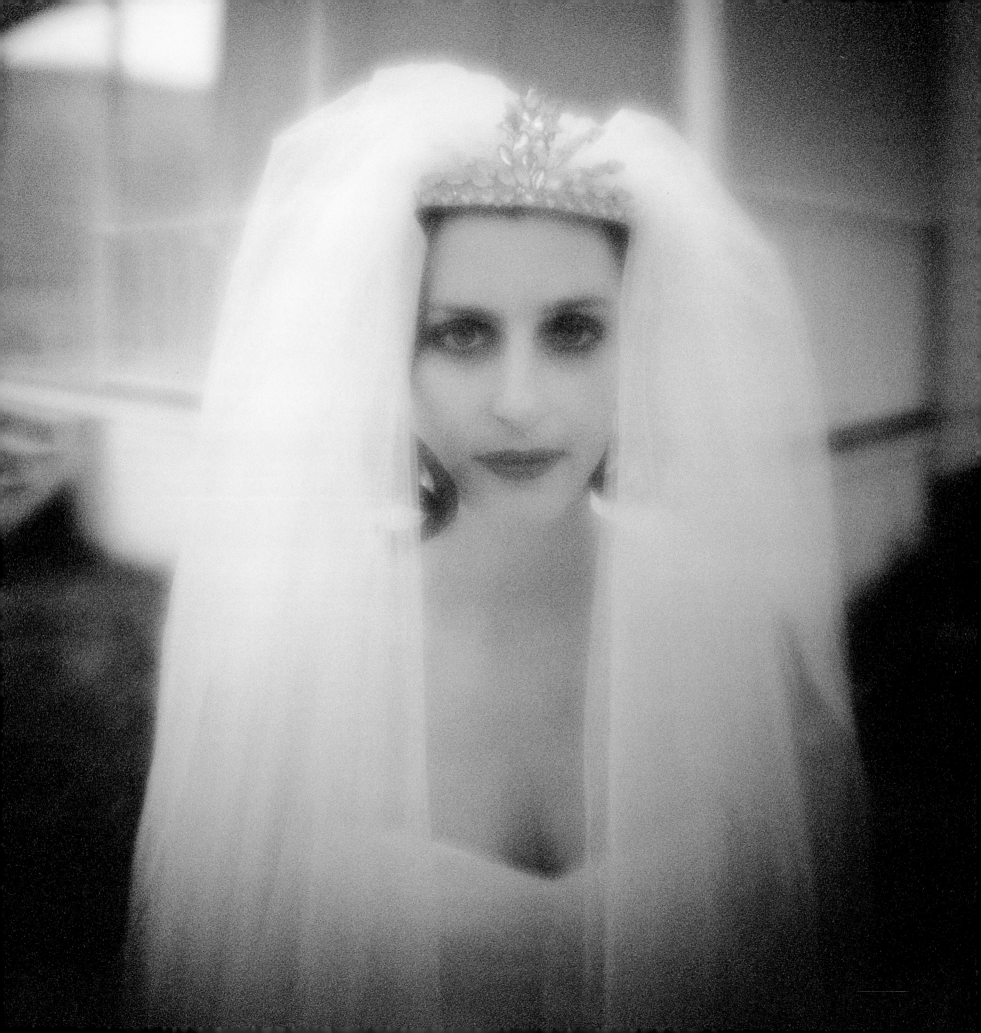

THE WEDDING DRESS

C L A R E G I B S O N

COURAGE
BOOKS
AN IMPRINT OF
RUNNING PRESS BOOK PUBLISHERS

DEDICATION

For John Gibson, Patricia Gibson,
and in memory of Margaret Lees (*née* Gibson).

Copyright © 2001 PRC Publishing Ltd

First published in the United States in 2001 by
Courage Books

Printed and bound in China

9 8 7 6 5 4 3 2 1
Digit on the right indicates the number of this printing

ISBN 0-7624-1119-8

First published in 2001 by
PRC Publishing Ltd,
8–10 Blenheim Court, Brewery Road, London N7 9NY
A member of the Chrysalis Group plc

Published by Courage Books, an imprint of
Running Press Books Publishers

Page 2: Bride with veil, 2000.
Right: Lady Alice Scott, later Princess Alice, about to marry the Duke of Gloucester, 1936.

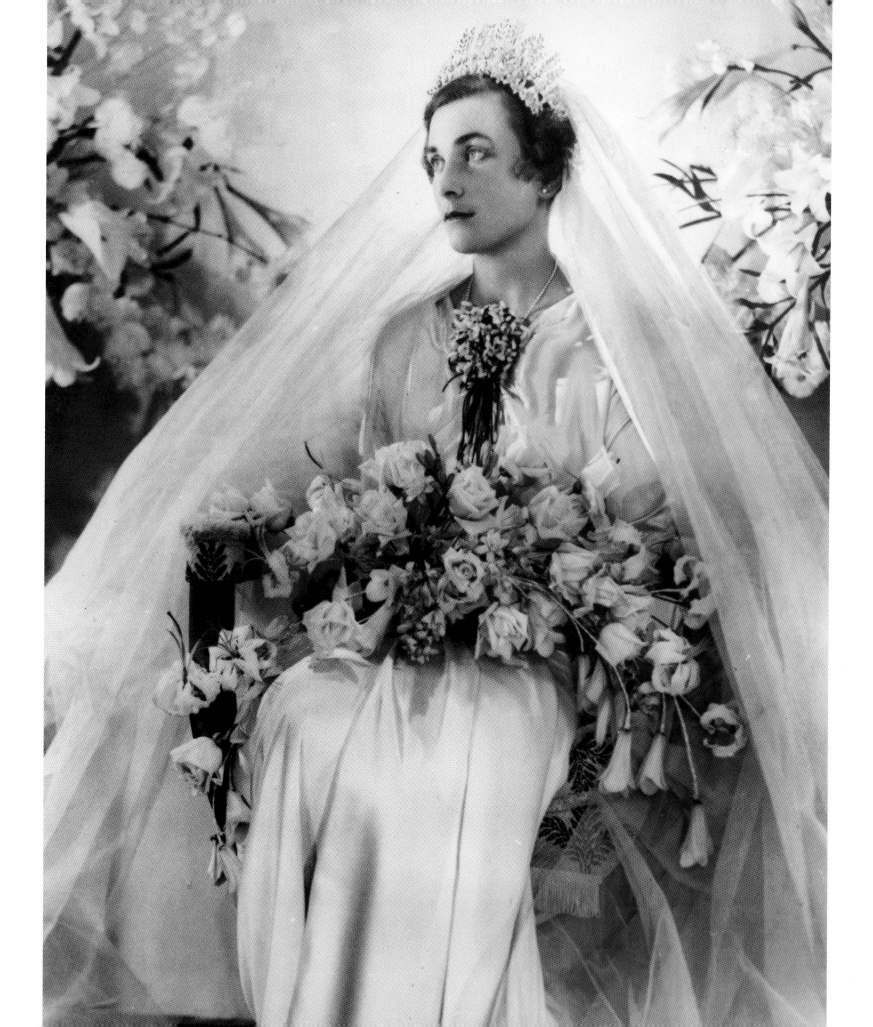

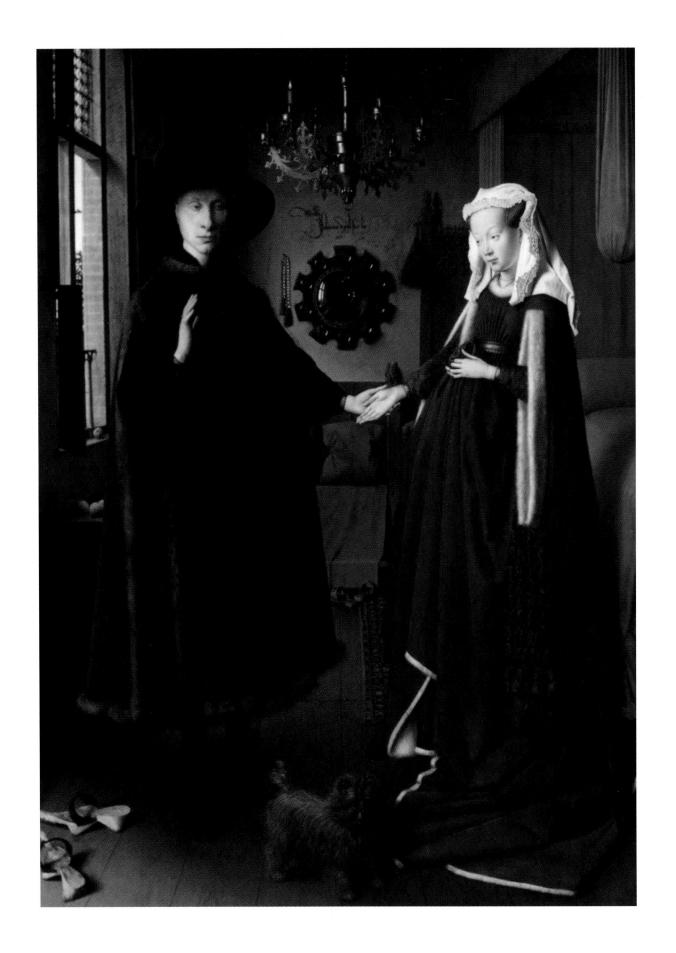

INTRODUCTION

The door opened, and the princess emerged with her golden hair and sparkling eyes. She was dressed in her silk gown, and it was as if an angel had descended from heaven into the room. She went directly to her father and mother and embraced and kissed them. They could not help weeping for joy. The young count was standing next to them, and when she noticed him, her cheeks turned as red as a moss rose.

Jacob and Wilhelm Grimm, *Die Gänsehirtin am Brunnen* ("The Goose Girl at the Spring") (1843).

Most little girls (and older ones, too) dream of a fairy-tale wedding in which they will make as bewitching a bride as the princess described by the Brothers Grimm above. Handsome prince apart, in the fantasy scenario of fairy tales, an enchanting wedding dress plays a leading role, and the bridal gown that today's embryonic brides dream about is, no doubt, fabulously romantic, indescribably beautiful, and, above all, white. After all, both fairy tales and tradition stipulate that a white wedding dress, whose color proclaims the wearer's purity and innocence, is an essential prerequisite for living happily ever after – or do they?

In fact, not only are none of the Grimms' fairy-tale brides described as wearing white, nor are the brides depicted by medieval artists. In the exquisitely detailed vignette devoted to the month of April in the *Très Riches Heures du Duc de Berry* (1416), for example, the bride wears a royal-blue gown, while Jan van Eyck's bride in *The Marriage of Giovanni Arnolfini and Giovanna Cenami* (1434) is swathed in emerald green. Paralleling fine art, although references to weddings and bridal attire have often been made in the chronicles of Western history and in literature, white-garbed brides feature rarely. Take, for instance, the narrator's sober description of his bride's gown in Oliver Goldsmith's *The Vicar of Wakefield* (1766): "I . . . chose my wife, as she did her wedding gown, not for a fine glossy surface, but such qualities as would wear well." or Charles Dickens's description of Miss Skiffins's appearance as she prepared to take her wedding vows in *Great Expectations* (1861): "That discreet damsel was attired as usual, except that she was now engaged in substituting for her green kid gloves, a pair of white."

The truth is, is that it is only in the past few centuries that the ideal wedding dress of the majority of brides has been envisaged as being both white and a

The Marriage of Giovanni Arnolfini and Giovanna Cenami, by Jan van Eyck, 1434.

7

one-off creation, to be worn on their wedding day and no other. Although the brides of earlier ages would certainly have dressed as well as their financial means and social position allowed, because their wedding dress was destined to be worn time and time again for "best," a white gown have been frowned upon as an unnecessarily expensive, impractical, and possibly even immodest, choice. Thrift was simultaneously a virtue and a necessity before mass-production brought "dedicated" wedding dresses within the reach of all but society's richest women, in an age when modesty in both dress and demeanor were furthermore demanded of the feminine sex. Indeed, George Eliot's touching description of Dinah's wedding in *Adam Bede* (1859) portrays a bride of whom contemporary readers would have wholeheartedly approved.

> *I envy them all the sight they had when the*
> *marriage was fairly ended and Adam led Dinah*
> *out of the church. She was not in black this*
> *morning; for her aunt Poyser would by no means*
> *allow such a risk of incurring bad luck, and had*
> *herself made a present of the wedding dress,*
> *made all of grey, though in the usual Quaker*
> *form, for on this point Dinah could not give way.*
> *So the lily face looked out with sweet gravity*
> *from under a grey Quaker bonnet, neither*
> *smiling nor blushing, but with lips trembling a*
> *little under the weight of solemn feelings.*

Nineteenth-century convention may have dictated that ordinary women should dress in muted colors and modest styles for their wedding day, but royal brides, then as now, were expected to bedazzle both their grooms and the watching congregation with the magnificence of their attire. And it is not with a fairy-tale princess, but a flesh-and-blood queen, that the story of the wedding dress as we know it – feminine, romantic, and white – begins.

QUEEN FOR A DAY

"Had my hair dressed and the wreath of orange flowers put on . . . I wore a white satin gown with a very deep flounce of Honiton lace, imitation of old. I wore my Turkish diamond necklace and earrings, and Albert's beautiful sapphire brooch . . ." This is just part of the lengthy entry that the queen of the United Kingdom since 1837, inveterate journal-keeper, and twenty-one-year-old bride made in her diary on February 10, 1840, the day of her wedding to Prince Albert of Saxe-Coburg-Gotha. By choosing a white bridal gown, Queen Victoria broke with the long-standing tradition that the royal brides of England be dressed in silver, instead perpetuating the general fashion for wearing white that had originated with the Neoclassical style that had become popular in Europe at the beginning of the nineteenth century. Just as

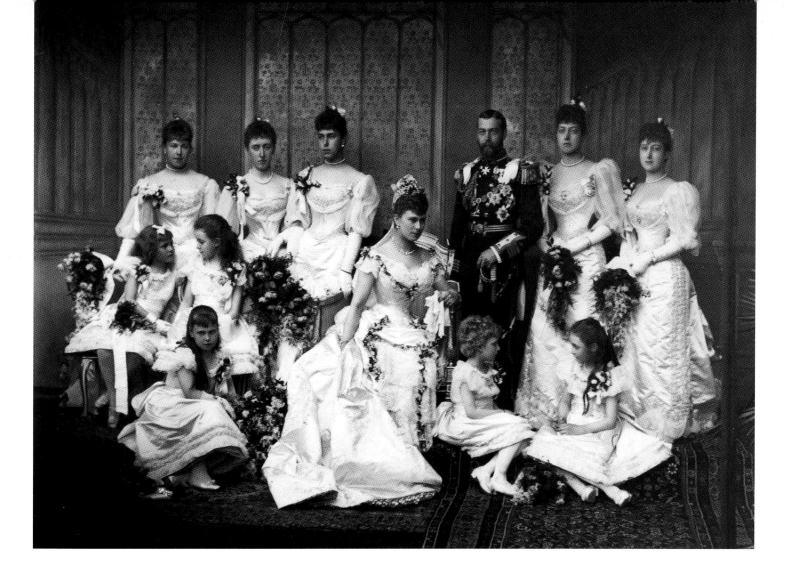

architects drew on ancient Greece and Rome for their inspiration following the French Revolution, so fashionable women followed the trend of clothing themselves in pale-hued, cotton or muslin "Empire-line" *robes en chemise* that emulated the elegant simplicity of the gowns worn by women depicted in Grecian art. And although fashions had changed dramatically by the time of Victoria's marriage, tightly laced waists and full skirts now being prescribed, white retained its association with unspoiled nature and innocence, qualities that have traditionally been prized in brides.

In her "wreath of orange flowers," Victoria was further echoing classical convention, for in Greco-Roman belief orange blossom symbolized fruitfulness and the bride's hope that the marriage would be blessed with children. Similarly, myrtle, as well as roses, were sacred to Aphrodite (Venus), the Greek goddess of love, while jasmine was considered the flower of Artemis (Diana) before its dedication to the Virgin Mary following the advent of Christianity. All of these flowering plants are now regarded as traditional bridal flowers, unlike the marjoram, basil, and rosemary with which classical brides also garlanded themselves.

The wedding in 1893 at Buckingham Palace of the Duke of York, later King George V (1865–1936), and Princess Mary of Teck (1867–1953). From left to right at the back: Princess Alexandra of Edinburgh, Princess Victoria of Schleswig-Holstein, Princess Victoria of Edinburgh, the Duke of York, Princess Victoria of Wales, Princess Maud of Wales. From left to right at the front: Princess Alice of Battenberg, Princess Beatrice of Edinburgh, Princess Margaret of Connaught, the Duchess of York, Princess Victoria of Battenberg, Princess Patricia of Connaught.

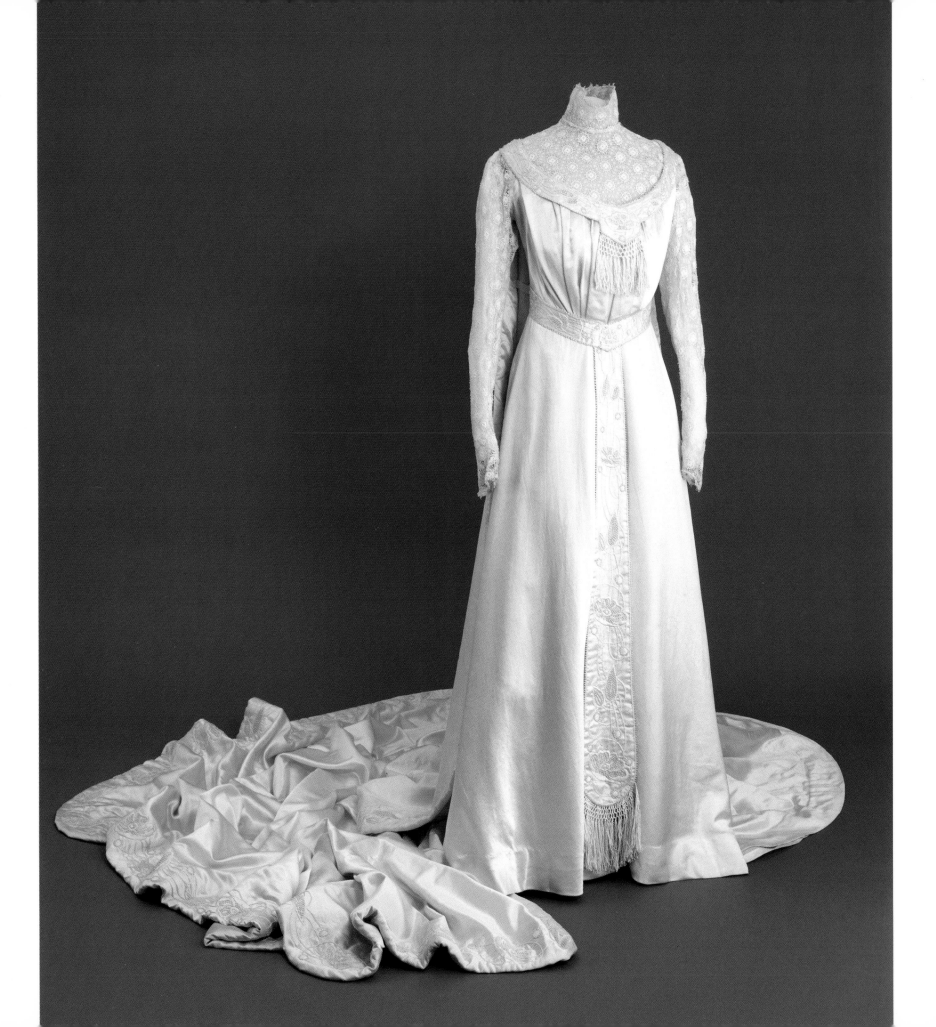

Although there is no photograph of Victoria in her wedding finery (the first-known surviving photograph of a bride being taken in 1854 in Boston, Massachusetts), we know that her daughters followed in her footsteps in their choice of wedding gown, starting with her eldest, Princess Vicky, who married Crown Prince Frederick of Germany in 1858. And for those brides-to-be who aspired – and could afford – to emulate royal bridal style, such photographs provided a rich source of inspiration. The majority of women, however, who could not afford the extravagance of a white wedding dress that could not realistically be worn again, invested in a new day-dress of silk taffeta in muted lavender or gray (the conventional colors of half-mourning at a time when the bereaved were strictly governed by etiquette) worn over a crinoline. Indeed, during the 1860s, a bonnet or veil – another nineteenth-century bridal innovation – trimmed with orange flowers was often the only indication of a woman's bridal status on her wedding day.

THE INCREASING SOPHISTICATION OF THE WEDDING DRESS

Like her sisters before her, when Victoria's daughter, Princess Louise, married the Marquis of Lorne in 1871, her wedding gown excited much interest. In accordance with current fashion, the folds of her long, ivory-colored gown were swept back over a horse-hair-stiffened bustle positioned over her *derrière*, while a court train flowed from her shoulders. Following the trendsetting princess's example, many high-society brides chose a similar style that could subsequently be adapted to act as an evening gown, although other women continued to wear day dresses whose underskirts, until the end of the 1870s, at least, were elongated at the back to form a short train. Indeed, while romantic evening styles in ivory taffeta were favored by affluent brides until the end of the nineteenth century, many women continued to opt for practical day dresses, sometimes in the jewel-like colors that had been introduced following the invention of synthetic aniline dyes, with tight-fitting, elaborately trimmed bodices, leg-of-mutton sleeves, and skirts that fell to the ground in elegant folds.

The death of Victoria in 1901 heralded the advent of the less strait-laced Edwardian age, in which the fashionable woman's silhouette dissolved into undulating lines, the illusion of softness projected, however, being firmly underpinned by "S"-shaped corsets. This trend affected bridalwear, too, as was not only seen in the voluptuous curves that the *Belle Époque* wedding gown emphasized, but also in brides' preference for lightweight fabrics like floating chiffon, delicate lace, and silky ninon rather than the stiffly formal satin or taffeta of the Victorian age. The

Wedding dress from Liberty & Co., a London department store, c. 1906.

division of wedding-dress styles into two distinct categories determined by the bride's social status persisted, however, as did the convention that her wedding gown be worn after her marriage, evening gowns being fashioned from long, frothy bridal confections and the newly fashionable, ankle-length, two-piece tailored suits worn by brides of more straitened financial circumstances subsequently serving as daywear.

WAR-TIME WEDDING GOWNS

Both of the twentieth-century's world wars lent a sense of urgency to weddings. Not only was there a real possibility that the bridegroom-to-be would literally not survive a protracted engagement, but the short notice of a brief period of home leave given to serving soldiers resulted in many hastily contracted marriages for which the bride had no time to prepare an elaborate wedding dress. In any case, women were for the first time taking on their absent menfolk's jobs, the practical demands of their war work having a direct effect on the fashions that dominated the years between 1914 and 1918, as well as from 1939 to 1945.

Hemlines rose steadily during World War I, partly to enable ease of movement for working women and partly in response to the increasing scarcity of fabric, a side effect of military conflict that, during World War II, resulted in the strict rationing of fabric in Europe, along with the stipulation that women's clothes conform to a government-approved, utilitarian style. As a result, women often married in practical, everyday suits and, during the second world conflict, sometimes even uniform. And when dresses that we would today recognize as being conventional wedding gowns were worn, they were generally relatively plain affairs, skirts becoming increasingly shorter as World War I progressed, in contrast to the years of World War II, when the narrow, floor-length styles of the carefree 1930s were clung to, albeit with the addition of such distinctive 1940s' details as square or sweetheart necklines and padded or yoked shoulders.

POSTWAR *JOIE DE VIVRE*

Following the armistice of 1918, people attempted to pick up the threads of their prewar existence. It was clear, however, that the traumatic war years had wrought such profound changes that things could never be the same again. During the 1920s, the emancipation of women's fashions that had begun in response to the demands of war continued at breakneck speed, crippling corsets being jettisoned, waistlines dropping to hip level, and skirts rocketing upward until they eventually skimmed the knees. Although the appearance of the androgynous flappers of the Jazz Age

shocked many conservative people, they dressed modestly by today's standards, and while they may have been corsetless, they still disguised their curves with constricting bodices.

As in the nineteenth century, British royal weddings set the standard for bridal fashion during the 1920s, particularly that of Princess Mary (the daughter of King George V), who married Henry, Viscount Lascelles in 1922. Her fabulous wedding dress, which combined both traditional and modern details, was described by *The Times* newspaper as "a Princess gown of cloth of silver, veiled with an overdress of ivory marquisette which is embroidered in silver and pearls. There is a full Court train of specially woven Duchess satin shot with silver. A deep border of lace cascades at the sides . . ." Another notable wedding was that of Princess Mary's bridesmaid, Lady Elizabeth Bowes-Lyon (today known as the Queen Mother), who married the Duke of York, the future King George VI, in the following year. Although she, too, wore a nearly floor-length, silver and ivory bridal gown, many of her contemporaries

A yeoman warder at the Tower of London photographed before giving away his daughter
at the Chapel of St. Peter ad Vincula, an ancient chapel near the White Tower, August 1927.

preferred ankle- or calf-length wedding dresses in cream or pastel shades.

Toward the end of the 1920s, skirt lengths dropped significantly at the back, heralding the elegantly elongated silhouette that would prevail during the 1930s, a decade during which femininity, rather than androgyny, became the fashionable woman's watchword, due in part to the influence of the era's glamorous movie stars, who smoldered seductively at their audiences from silver screens the world over. Although skirts remained narrow, they dropped to mid-calf for day- and to the floor for eveningwear, the combination of the popular Princess line and soft, often bias-cut, fabrics like silky jersey and *crêpe de chine* serving to emphasize feminine curves and lengthen legs. Although some women chose a belted and tailored day suit in which to wed, or else a long, flowing, "garden-party" dress topped with a bolero jacket, many fell in love with the sheer romance of the lavish gowns – often based on historical costumes or evening gowns – that they saw modeled by the movie stars that they adopted as role models. And in accordance with the escapist mood of the decade, the icy purity of starkly white satin came increasingly to be regarded as the ideal wedding-dress fabric, that is, until the grim reality of war interrupted the fantasy.

In Europe, the celebration of V.E. and V.J. days in 1945 could not hide the drabness of the war-torn countries. Two events brightened the postwar year of 1947: one was the marriage in Britain of Princess Elizabeth (subsequently Queen Elizabeth II) to Philip Mountbatten, the other being the unveiling of his New Look by French couturier Christian Dior. With Britain still in the grip of clothes rationing, Princess Elizabeth's wedding dress was patriotically slender and relatively plain. In radical contrast, with their curve-hugging bodices, wasp waists, and padded hips that swelled above voluminous, calf-length skirts, Dior's New Look gowns both recalled the opulence of the nineteenth century and trumpeted an end to the pinched austerity of the war years, signaling an era in which luxury and beauty would celebrated. Many brides-to-be fell in love with the glamorous New Look, and wore Dior-inspired suits on their wedding days.

WEDDING DRESSES IN THE ERA OF CONSPICUOUS CONSUMPTION

From the "A" through the "H" to the "Y" line, in the aftermath of World War II, Parisian couturiers – not least Monsieur Dior – were responsible for introducing a veritable alphabet soup of silhouettes to women's fashion. Indeed, the 1950s marked the beginning of an era of rapid change and conspicuous consumption that has continued to this day. Wedding-dress styles continued to fall into long and short categories, the floor-length exemplars being typically

Sketch of Norman Hartwell's design for the wedding dress of Princess Elizabeth (later Queen Elizabeth II), 1947.

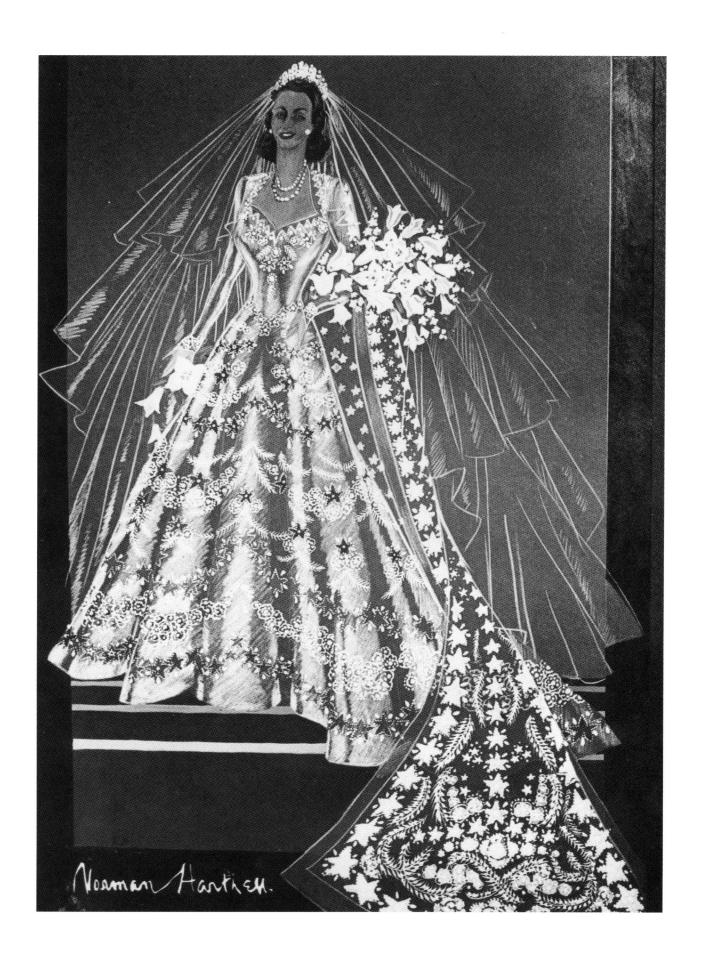

Norman Hartnell.

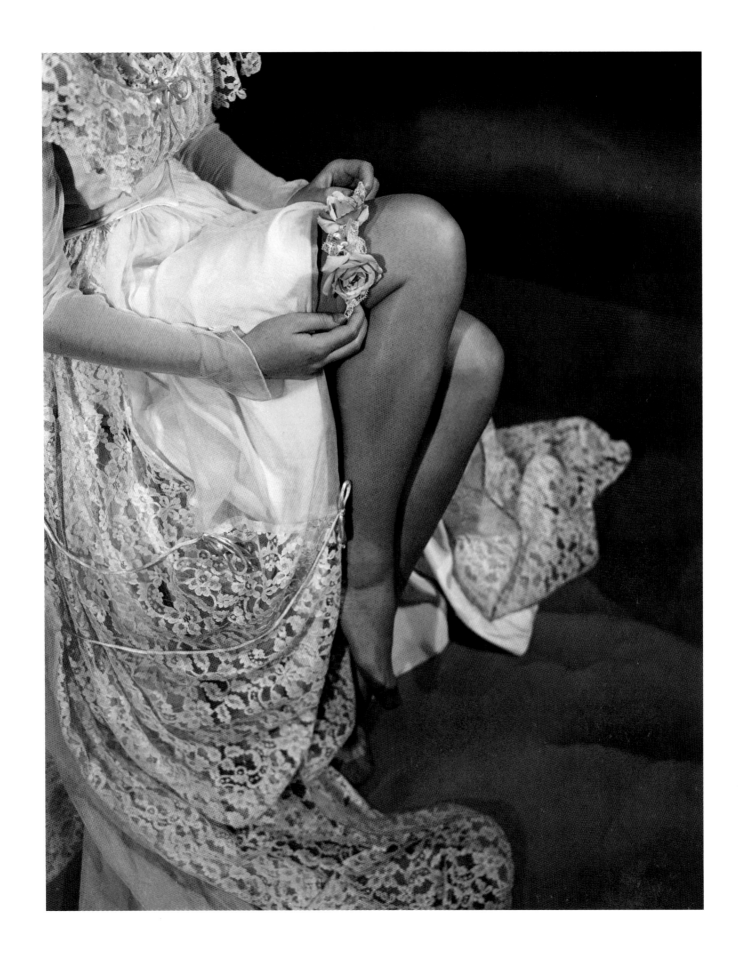

white, sloping-shouldered, tight-waisted, and full-skirted (calf-length versions were also popular, their skirts given buoyancy by stiffened petticoats), while more practical brides chose to be married in slender, tailored dresses worn under short, close-fitting jackets. Whatever their style, however, during the decade in which the movie star Grace Kelly married Prince Rainier III of Monaco, most bridal gowns were relatively conservative, reflecting the prevailing convention that women should, above all, be ladylike, a stifling ideal that the women of the decade that followed would do their best to shake off.

As well as embracing the miniskirts and -dresses first introduced by British designer Mary Quant in 1958, during the adventurous 1960s, many brides-to-be took their inspiration from the fashions of the Victorian, Edwardian, and even Regency era (seen in the reinvention of the Empire line), while those who espoused hippie counterculture preferred to be wed in the fabrics, motifs, and styles that evoked an Indian, peasant, or Bohemian look. All of these influences were carried through into the 1970s, apart from the mini, which was superseded by the more dignified maxiskirt. The fantasy trend continued throughout the 1980s,

fueled in 1981 by the marriage of Lady Diana Spencer, who floated up the aisle in a fairy-tale creation designed by the Emmanuels to exchange vows with Prince Charles, heir to the British throne.

Although a long, white wedding gown remained the preferred choice of the traditionally minded bride, throughout the flamboyance of the 1980s, as well as the restrained elegance of the 1990s, it seemed that anything went – even pantsuits – and, indeed, as a direct result, the twenty-first-century bride has inherited a dressing-up box containing wedding gowns of every age. Be it the straight silhouette of Grecian, medieval, flapper-, or Empire-line gowns, the voluptuous curves drawn from the annals of Elizabethan, Victorian, Edwardian, or New Look fashions, a day, afternoon, or evening dress embellished – or not – by such accessories as veils, hats, and floral headdresses, together her predecessors have presented the third-millennium bride with a treasury of inspirations as their wedding gift. And, whatever her choice, she can be secure that, in the words of the nineteenth-century English playwright Douglas Jerrold,

There is something about a wedding-gown
Prettier than any other gown in the world.

Garter trimmed with roses, c. 1950.

May heaven grant you in all things your heart's desire: husband, house and a happy, peaceful home. For there is nothing better in this world than that a man and woman, sharing the same ideas, keep house together. It discomforts their enemies and makes the hearts of their friends glad – but they themselves know more about it than anyone.

HOMER, *THE ODYSSEY* (EIGHTH CENTURY B.C.).

MARRIED LOVE BETWEEN

MAN AND WOMAN IS BIGGER THAN OATHS

GUARDED BY RIGHT OF NATURE.

AESCHYLUS, THE EUMENIDES *(458 B.C.)*.

ARISTOCRATIC WEDDING, *by Sano di Pietro, c. 1450.*

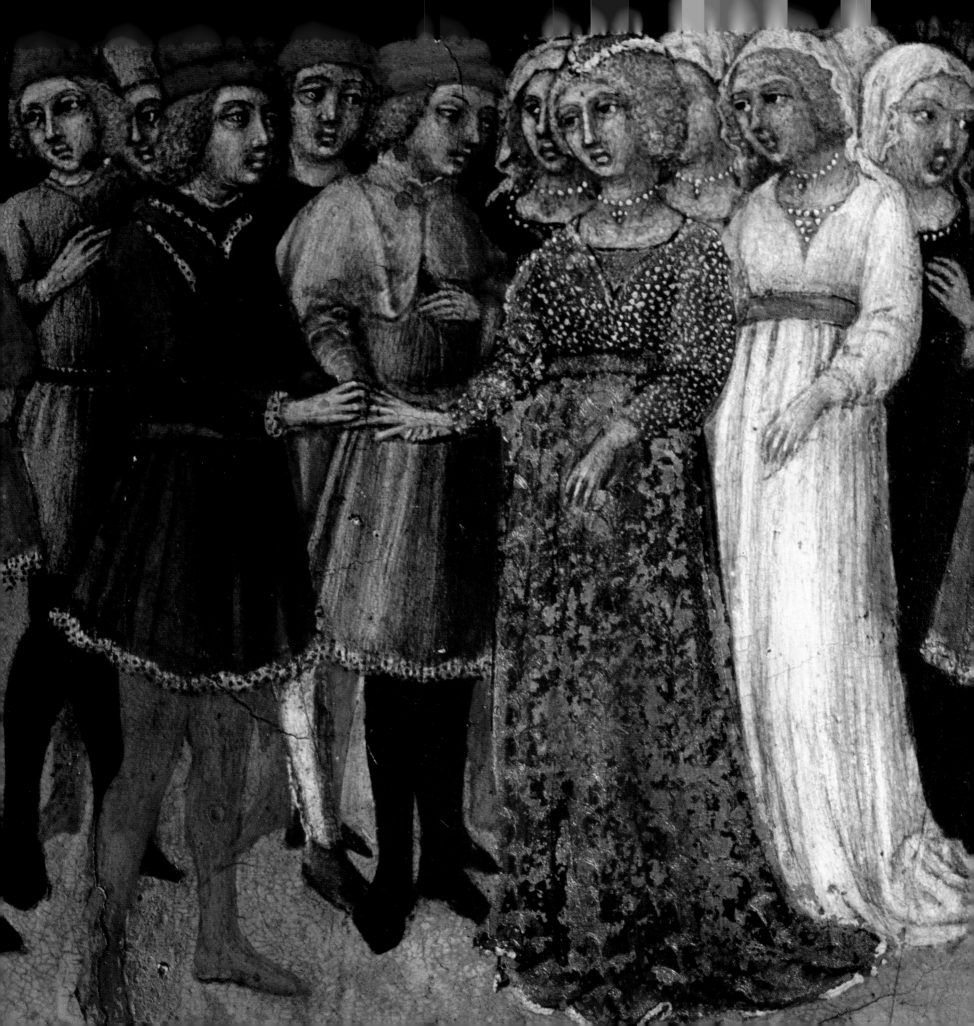

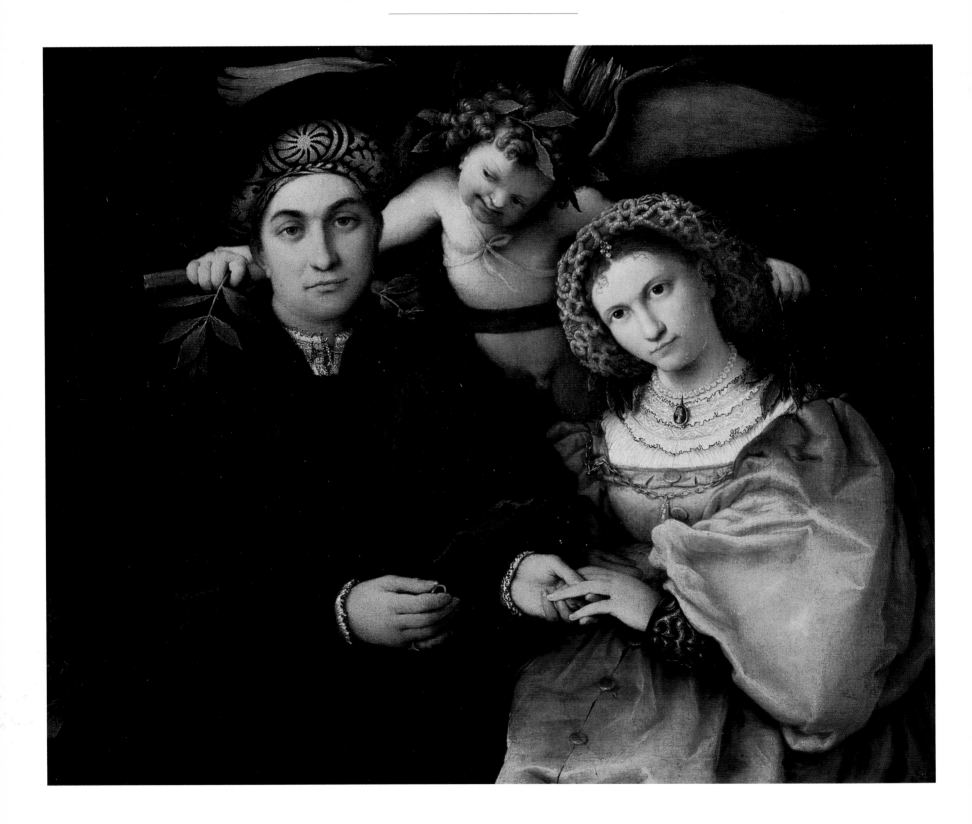

Can a maid forget her

ORNAMENTS, OR A BRIDE HER ATTIRE?

The Bible, Jeremiah 2:32.

Whoso findeth a wife findeth a good thing.

THE BIBLE, PROVERBS 18:22.

CAN TWO WALK TOGETHER,

EXCEPT THEY BE AGREED?

The Bible, Amos 3:3.

Portrait of Messer Marsilio and his bride, 1523.

M AN'S BEST POSSESSION IS A SYMPATHETIC WIFE.

Euripides, ANTIGONE, *164 (c.5th century B.C.)*

One man should love and honor one:

A bride-bed

Theirs alone till life's done.

EURIPIDES, *ANDROMACHE* (C.436 B.C.).

An engraving of the bridal gown of a lady from Cologne, Germany, 1577.

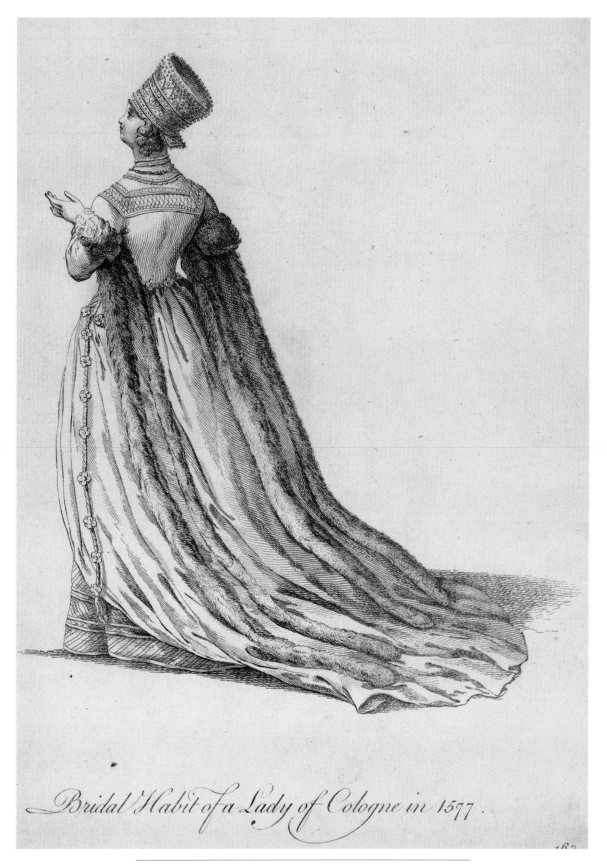

Bridal Habit of a Lady of Cologne in 1577.

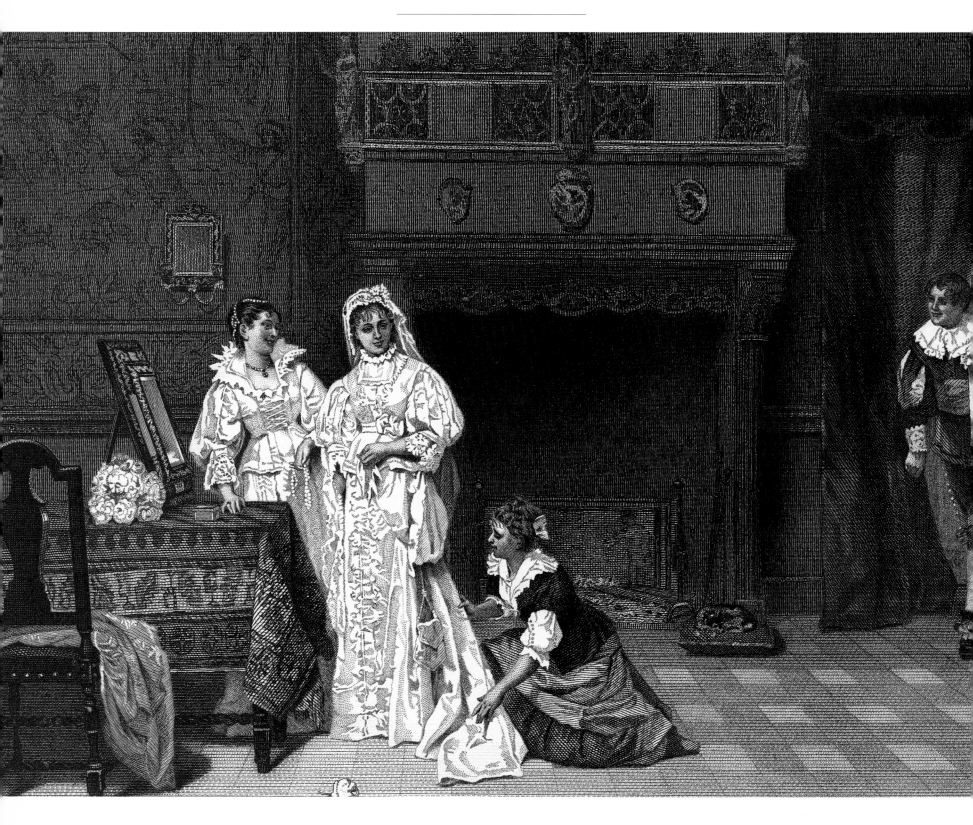

What matters is not that a married couple should be equal in wealth, but that their minds and manners should be compatible; integrity and modesty are a girl's best dowry.

TERENCE (C.185–159 B.C.).

WHAT DEARER THING HAS THE WORLD TO OFFER THAN A WOMAN WHO CAN GLADDEN A YEARNING HEART?

Walther von der Vogelweide (c.1170–c.1230).

Marriage is such a long-lasting condition that it should not be undertaken lightly, nor without the approval of our closest friends and relations.

MARGARET OF NAVARRE, *HEPTAMÉRON* (1559).

A bride gets ready for her wedding, artist unknown, c. seventeenth century.

Married in white, you have chosen all right,

Married in green, ashamed to be seen,

Married in grey, you will go far away,

Married in red, you will wish yourself dead,

Married in blue, you will always be true,

Married in yellow, ashamed of your fellow,

Married in black, you will wish yourself back,

Married in pink, of you he'll think.

TRADITIONAL ENGLISH RHYME.

A demure bride whose wedding dress is in Pre-Raphaelite style, c. 1860.

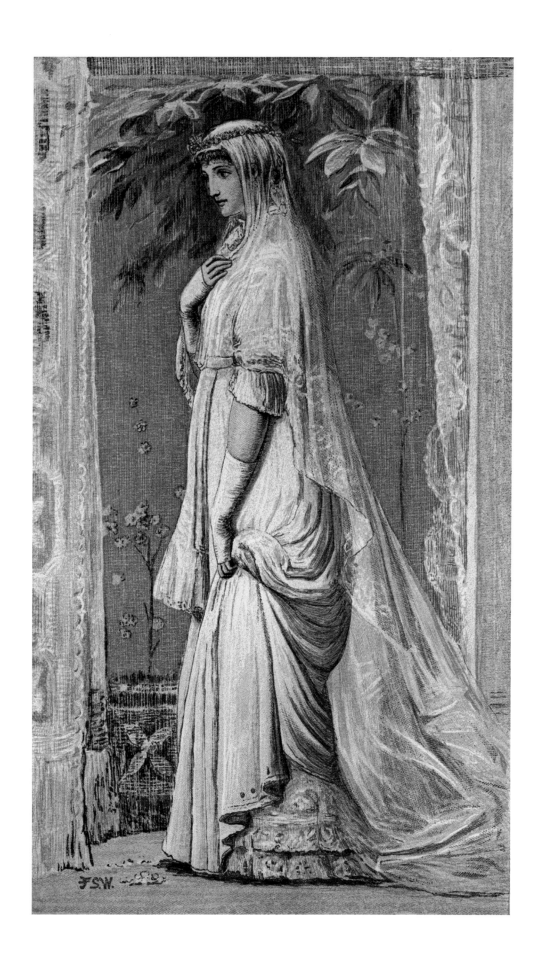

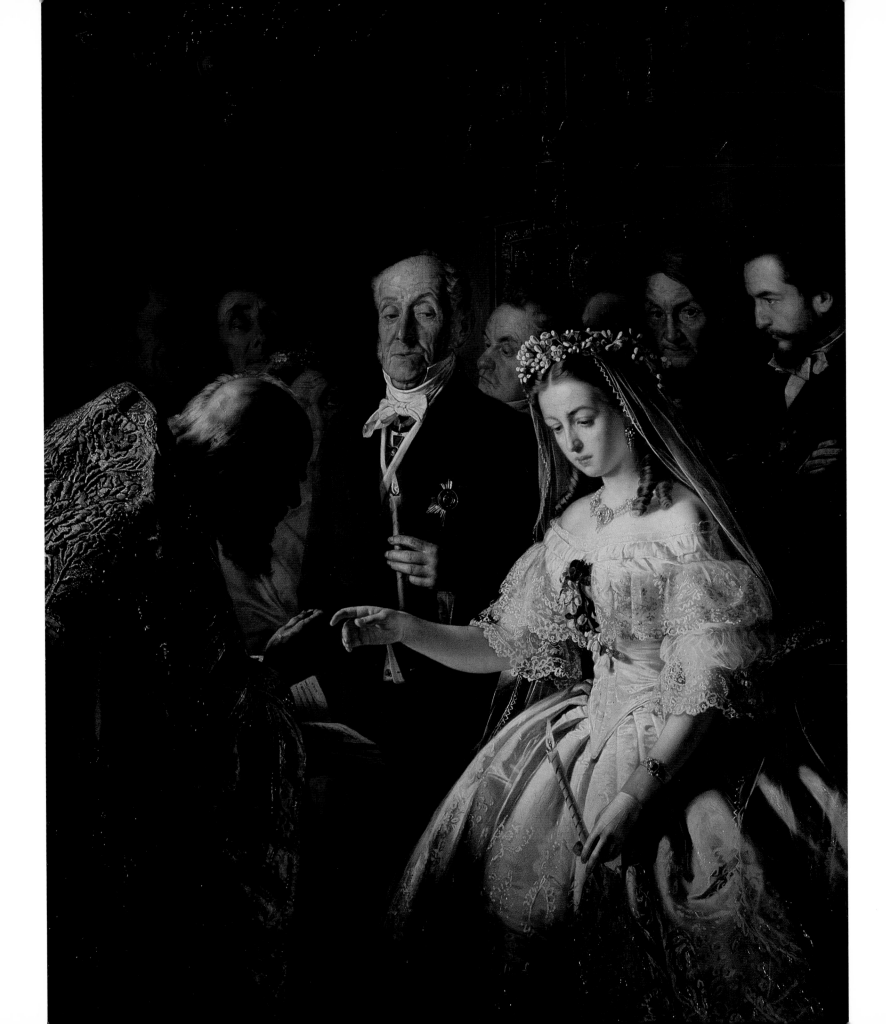

MARRIED IN JANUARY'S HOAR AND RIME,
WIDOWED YOU'LL BE BEFORE YOUR PRIME.
MARRIED IN FEBRUARY'S SLEEPY WEATHER,
LIFE YOU'LL TREAD IN TIME TOGETHER.
MARRIED WHEN MARCH WINDS SHRILL AND ROAR,
YOUR HOME WILL BE ON A DISTANT SHORE.
MARRIED BENEATH APRIL'S CHANGING SKIES,
A CHEQUERED PATH BEFORE YOU LIES.
MARRIED WHEN BEES OVER MAY BLOSSOMS FLIT,
STRANGERS AROUND YOUR BOARD WILL SIT.
MARRIED IN THE MONTH OF ROSES – JUNE,
LIFE WILL BE ONE LONG HONEYMOON.
MARRIED IN JULY WITH FLOWERS ABLAZE,
BITTERSWEET MEMORIES ON AFTER DAYS.
MARRIED IN AUGUST'S HEAT AND DROWSE,
LOVER AND FRIEND IN YOUR CHOSEN SPOUSE.
MARRIED IN SEPTEMBER'S GOLDEN GLOW,
SMOOTH AND SERENE YOUR LIFE WILL GO.
MARRIED WHEN LEAVES IN OCTOBER THIN,
TOIL AND HARDSHIP FOR YOU GAIN.
MARRIED IN VEILS OF NOVEMBER MIST,
FORTUNE YOUR WEDDING RING HAS KISSED.
MARRIED IN DAYS OF DECEMBER CHEER,
LOVE'S STAR SHINES BRIGHTER FROM YEAR TO YEAR.

Traditional English rhyme.

THE UNEQUAL MARRIAGE, *by Vasili V. Pukirev, 1862.*

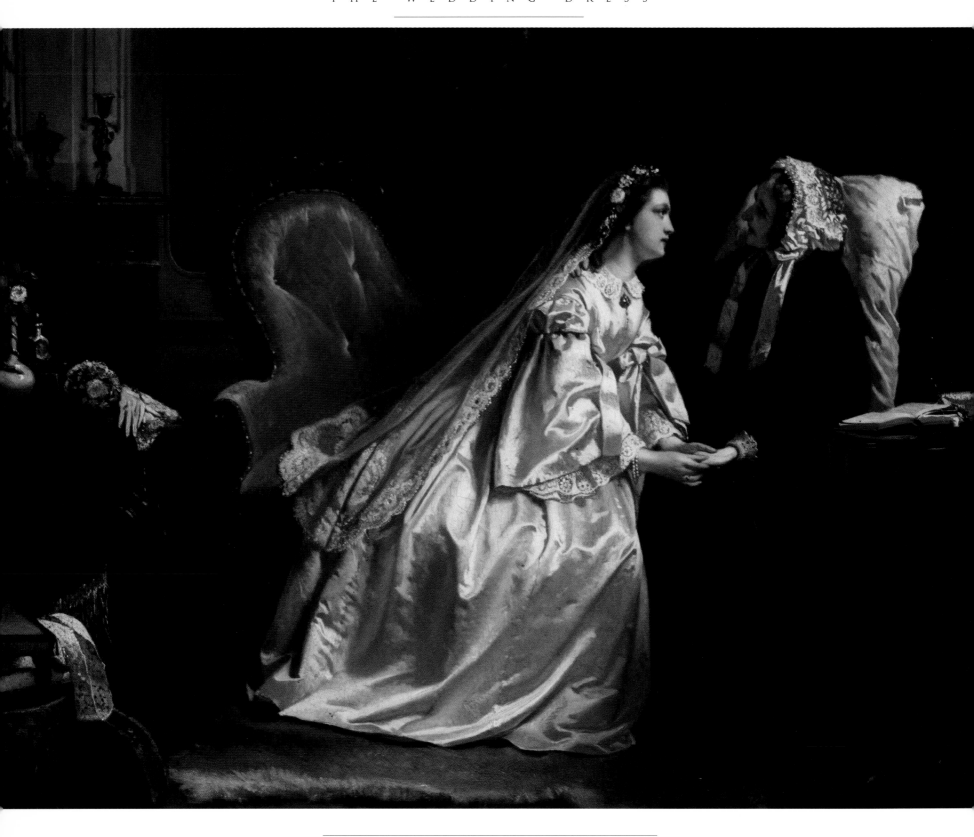

On Which Day of the Week to Marry?

S OMETHING OLD,

SOMETHING NEW,

SOMETHING BORROWED,

SOMETHING BLUE.

Monday for wealth,

Tuesday for health,

Wednesday the best day of all;

Thursday for crosses,

Friday for losses,

Saturday for no luck at all.

The traditional bridal costume.

TRADITIONAL ENGLISH RHYME.

T HERE IS NO MORE LOVELY, FRIENDLY AND CHARMING

RELATIONSHIP, COMMUNION OR COMPANY THAN A GOOD MARRIAGE.

Martin Luther, TABLE TALK *(1569).*

SOME GOOD ADVICE, *by Hendrik Jacobus Scholten, late nineteenth century.*

Sonnet 116

Let me not to the marriage of true minds

Admit impediments. Love is not love

Which alters when it alteration finds,

Or bends with the remover to remove.

O, no! It is an ever fixed mark,

That looks on tempests and is never shaken;

It is the star to every wand'ring bark,

Whose worth's unknown, although his height be taken.

Love's not Time's fool, though rosy lips and cheeks

Within his bending sickle's compass come;

Love alters not with his brief hours and weeks,

But bears it out even to the edge of doom.

If this be error and upon me proved,

I never writ, nor no man ever loved.

WILLIAM SHAKESPEARE (1609).

Cream satin trimmed with machine lace, British, 1885.

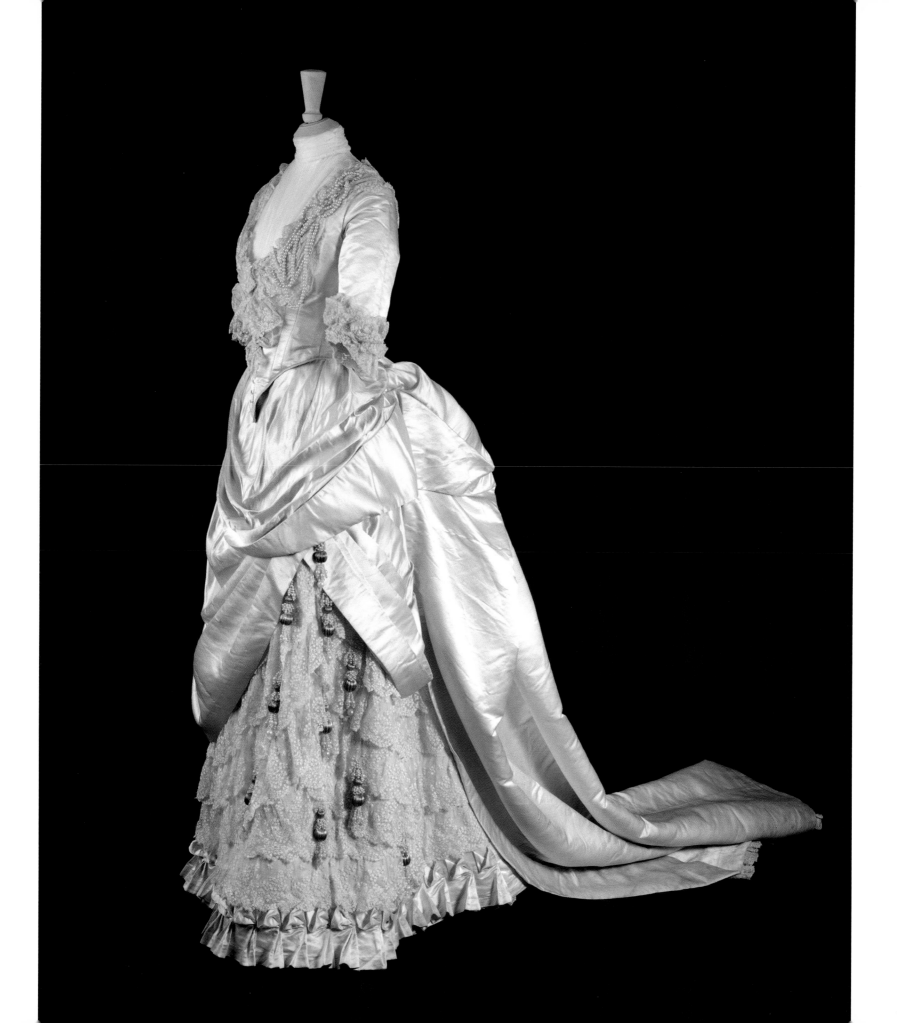

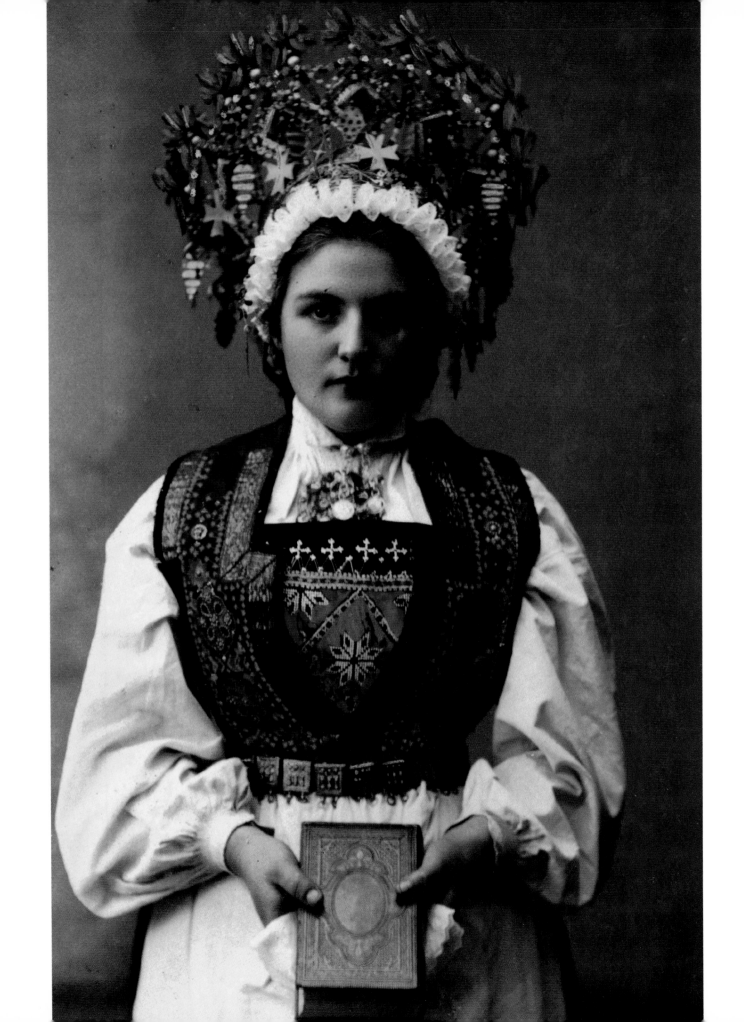

JULIET: THREE WORDS, DEAR ROMEO, AND GOOD NIGHT INDEED. IF

THAT THY BENT OF LOVE BE HONOURABLE,

THY PURPOSE MARRIAGE, SEND ME WORD TOMORROW

BY ONE THAT I'LL PROCURE TO COME TO THEE,

WHERE AND WHAT TIME THOU WILT PERFORM THE RITE,

AND ALL MY FORTUNES AT THY FOOT I'LL LAY,

AND FOLLOW THEE MY LORD THROUGHOUT THE WORLD.

William Shakespeare, ROMEO AND JULIET, *Act 2, Scene 2 (1594).*

They do not love that do not show their love.

WILLIAM SHAKESPEARE,
THE TWO GENTLEMEN OF VERONA,
ACT 1, SCENE 2 (1594-95).

A Norwegian bride wearing traditonal costume, c. 1900.

LET ALL THY JOYS BE
AS THE MONTH OF MAY
AND ALL THY DAYS BE AS A
MARRIAGE DAY.

Francis Quarles (1594–1644).

The joys of marriage are the heaven on earth,

Life's paradise, great princess, the soul's quiet,

Sinews of concord, earthly immortality,

Eternity of pleasures; no restoratives

Like to a constant woman.

JOHN FORD,
THE BROKEN HEART,
ACT 2, SCENE 2 (1633).

I SING OF BROOKS, OF BLOSSOMS, BIRDS, AND BOWERS:

OF APRIL, MAY, OF JUNE, AND JULY-FLOWERS.

I SING OF MAY-POLES, HOCK-CARTS, WASSAILS, WAKES,

OF BRIDE-GROOMS, BRIDES, AND OF THEIR BRIDAL-CAKES.

Robert Herrick, "The Argument of His Book," from HESPERIDES *(1648).*

Helena, wife of Prince Leopold, first Duke of Albany, 1905.

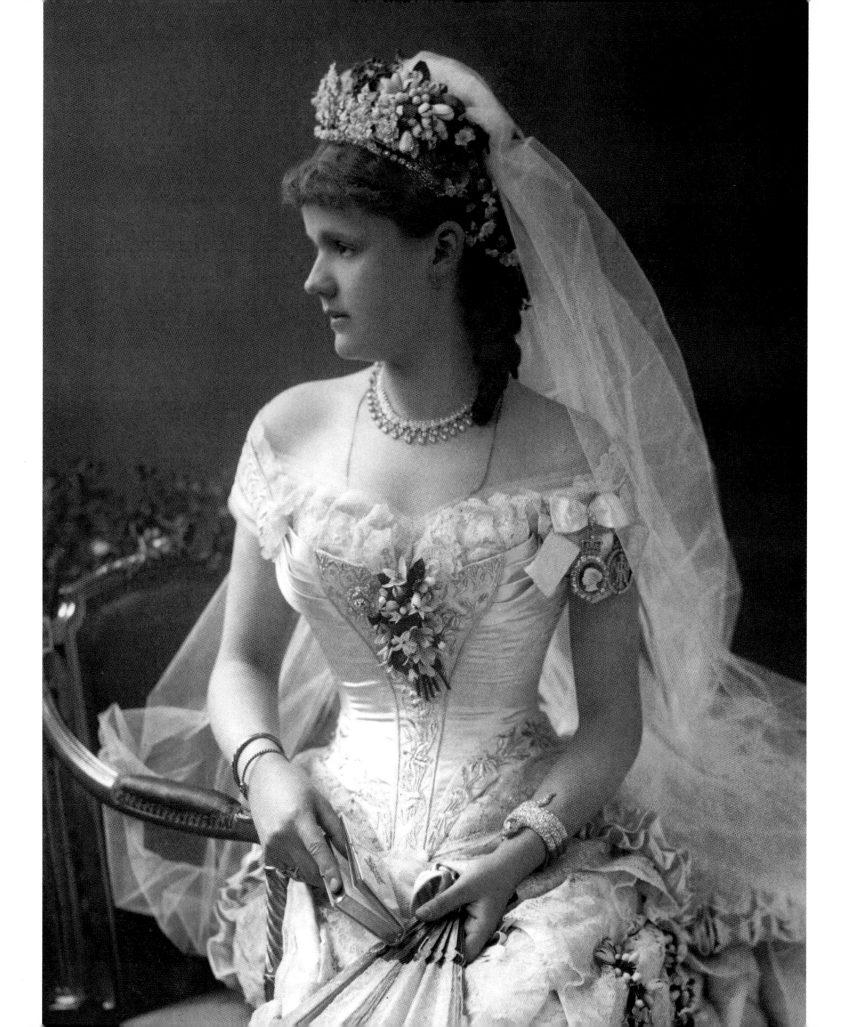

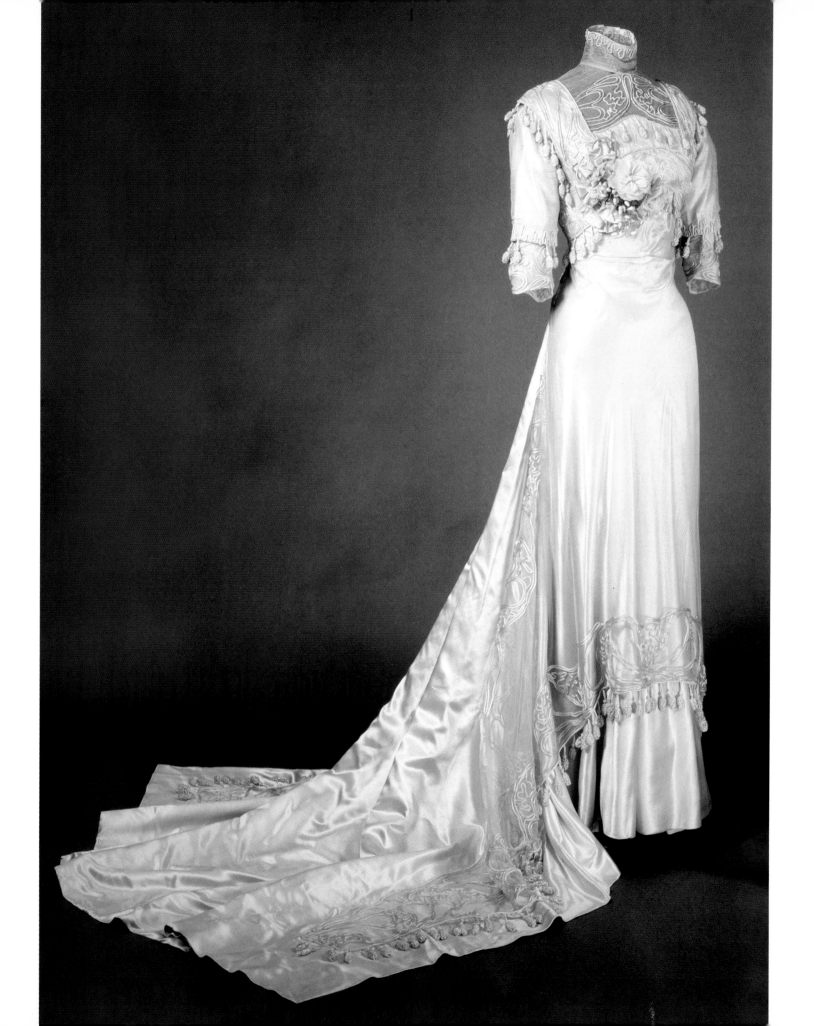

To My DEAR and Loving Husband

If ever two were one, then surely we.

If ever man were lov'd by wife, then thee;

If ever wife was happy in a man,

Compare with me ye women if you can.

I prize thy love more than whole Mines of gold,

Or all the riches that the East doth hold.

My love is such that Rivers cannot quench,

Nor ought but love from thee, give recompence.

Thy love is such I can no way repay,

The heavens reward the manifold I pray.

Then while we live, in love lets so persever,

That when we live no more, we may live ever.

Ann Bradstreet (1650).

French wedding dress of 1910.

Open the temple gates unto my love,
Open them wide that she may enter in,
And all the postes adorne as doth behove,
And all the pillours deck with girlands trim,
For to recyve this Saynt with honour dew,
That commeth in to you.
With trembling steps and humble reverence,
She commeth in, before th'almighties vew,
Of her ye virgins learne obedience,
When so ye come into these holy places,
To humble your proud faces:
Bring her up to th'high altar, that she may
The sacred ceremonies there partake,
The which do endless matrimony make,
And let the roring Organs loudly play
The praises of the Lord in lively notes,
The whiles with hollow throates
The Choristers the joyous Antheme sing,
That al the woods may answere and their eccho ring.
That all the woods may answere and your eccho ring.

Behold whiles she before the altar stands
Hearing the holy priest that to her speakes
And blesseth her with his two happy hands,
How the red roses flush up in her cheekes,
And the pure snow with goodly vermill stayne,
Like crimsin dyde in grayne,
That even th'Angels which continually,
About the sacred Altare doe remaine,
Forget their service and about her fly;
Ofte peeping in her face that seemes more fayre,
The more they on it stare.
But her sad eyes still fastened on the ground,
Are governed with goodly modesty,
That suffers not one looke to glaunce awry,
Which may let in a little thought unsownd.
Why blush ye love to give to me your hand,
The pledge of our band?
Sing ye sweet Angels, Allelluya sing,
That all the woods may answere and your eccho ring.

EDMUND SPENSER,
FROM *EPITHALAMION* (1595).

Now al is done; bring home the bride againe,
Bring home the triumph of our victory,
Bring home with you the glory of her gaine,
With joyance bring her and with jollity.
Never had man more joyfull day then this,
Whom heaven would heape with blis.

English wedding dress of 1911.

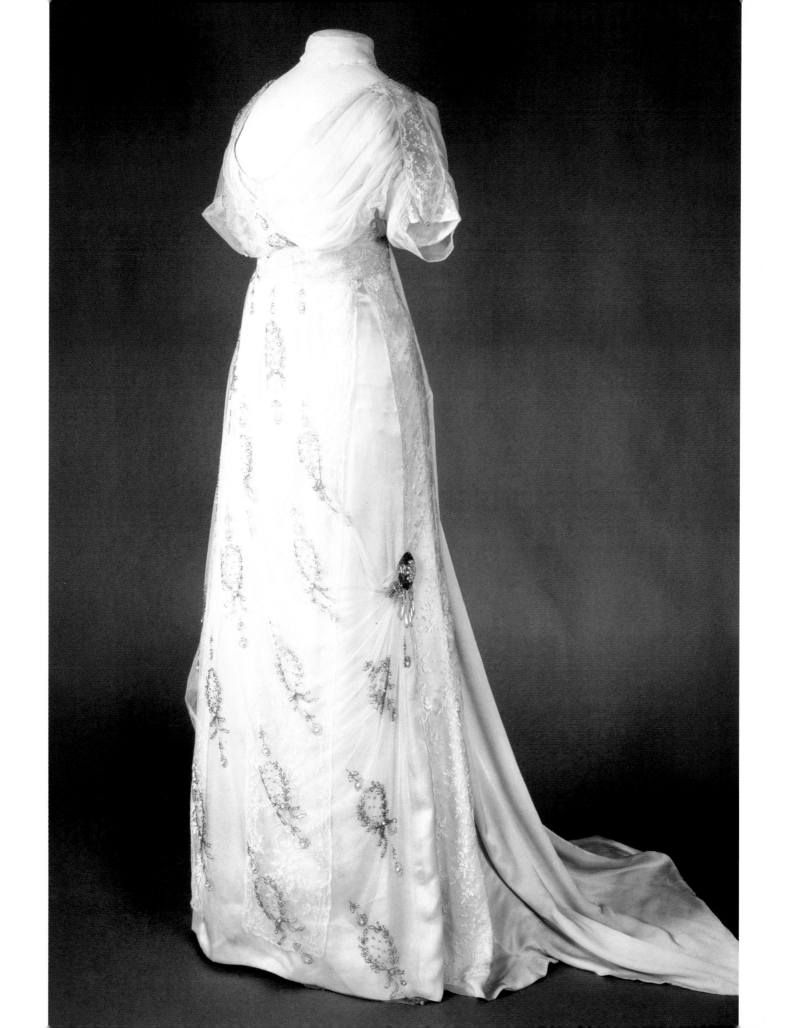

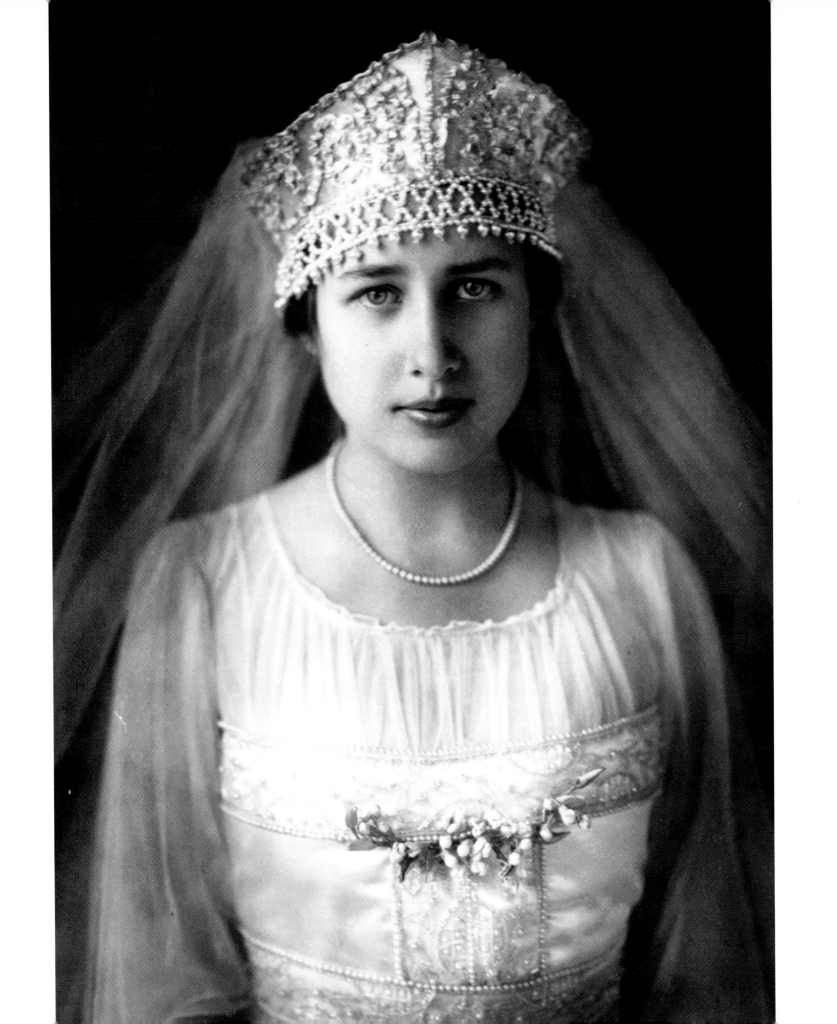

I WILL **WED** THEE IN ANOTHER KEY,

WITH POMP, WITH TRIUMPH AND WITH REVELING.

William Shakespeare, A MIDSUMMER NIGHT'S DREAM *(1595–96).*

The *sealing day* betwixt my love and me,

For everlasting bond of fellowship.

WILLIAM SHAKESPEARE,
A MIDSUMMER NIGHT'S DREAM (1595–96).

Honour, riches, marriage blessing,

Long continuance, and increasing,

Hourly joys be still upon you!

Juno sings her blessings on you.

WILLIAM SHAKESPEARE,
THE TEMPEST (1611–12).

Wedding-day portrait of Eleanor Clay, the bride of Henry Ford's son, Edsel, 1916.

Come live with me, and be my love, and we will some new pleasures prove, of golden sands, and crystal brooks, with silken line, and silver hooks.

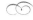

John Donne (1572–1631), from THE BAIT.

Drink to me only with thine eyes,

And I will pledge with mine;

Or leave a kiss but in the cup,

And I'll not look for wine.

BEN JONSON, "TO CELIA" (1616).

*Rose Patterson married Harold Gibson (standing, third from left) in Canterbury, Kent, England,
on September 3, 1923. Photographed surrounded by family members, the style of the bride's wedding dress is typical
of the early 1920s, in contrast to the groom's more conservative "morning dress."*

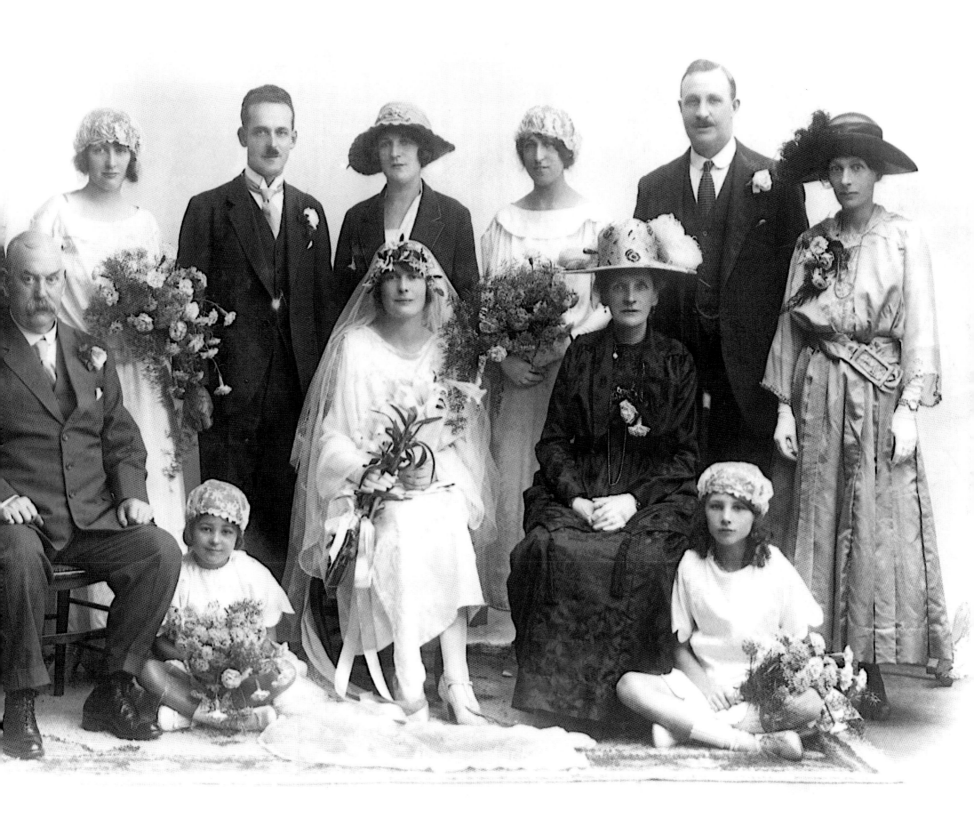

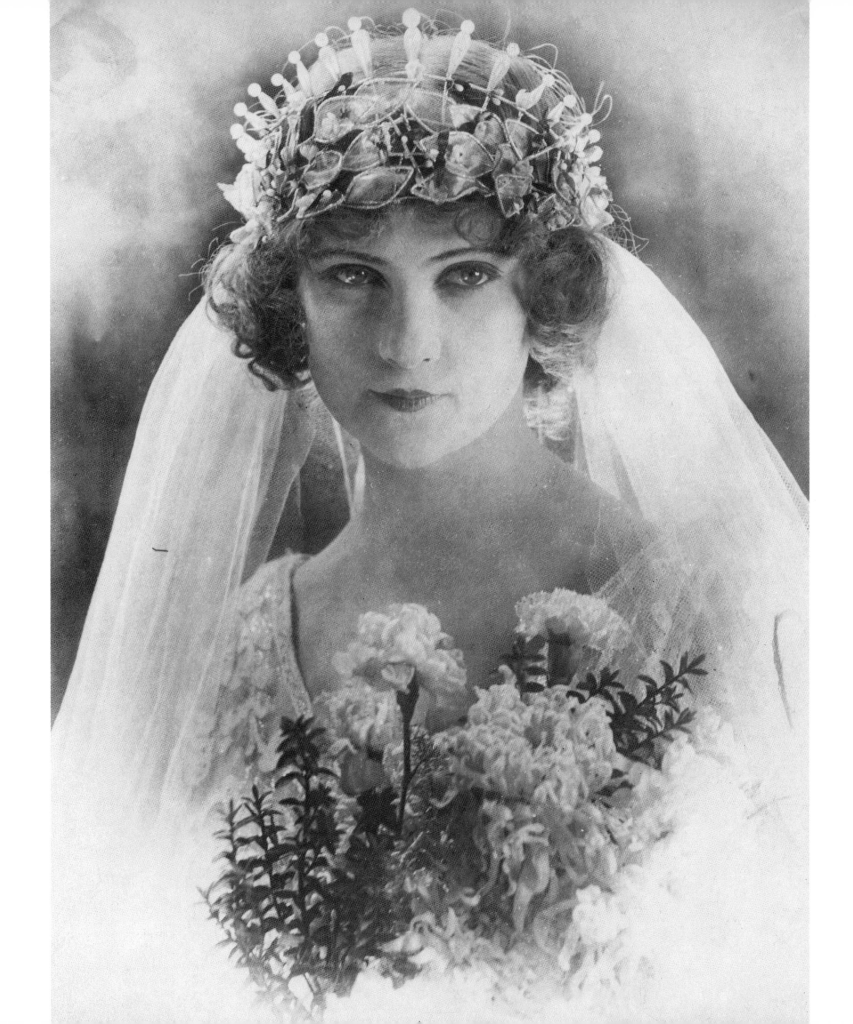

Dearly beloved, we are gathered here in the sight of

God, and in the face of this congregation, to join together this Man and

this Woman in holy Matrimony.

BOOK OF COMMON PRAYER (1662),
SOLEMNIZATION OF MATRIMONY EXHORTATION.

Wilt thou have this Woman to thy wedded

wife, to live together after God's ordinance in the holy

estate of Matrimony? Wilt thou love her, comfort her,

honour, and keep her in sickness and in health; and,

forsaking all other, keep thee only unto her, so long as

ye both shall live?

BOOK OF COMMON PRAYER (1662),
SOLEMNIZATION OF MATRIMONY EXHORTATION.

WITH THIS RING I THEE WED,

WITH MY BODY I THEE WORSHIP,

AND WITH ALL MY WORLDLY GOODS

I THEE ENDOW.

Book of Common Prayer (1662),
SOLEMNIZATION OF MATRIMONY
Exhortation.

Bride wearing a lace and pearl veil, 1920s.

God in the first ordaining of marriage taught us to what end he did it, in words expressly implying the apt and cheerful conversation of man with woman, to comfort and refresh him against the evil of solitary life, not mentioning the purpose of generation till afterwards, as being but a secondary end in dignity, though not in necessity.

JOHN MILTON,
THE DOCTRINE AND DISCIPLINE OF DIVORCE (1643).

HAIL, WEDDED LOVE, MYSTERIOUS LAW, TRUE SOURCE

OF HUMAN OFFSPRING, SOLE PROPRIETY

IN PARADISE OF ALL THINGS COMMON ELSE.

John Milton, PARADISE LOST, *4, 1.750 (1667).*

Wedding of Cheng Lo, daughter of the Chinese ambassador to France, and Raymond Y. C. Wang, attaché at the legation at Berne, Switzerland, May 19, 1924.

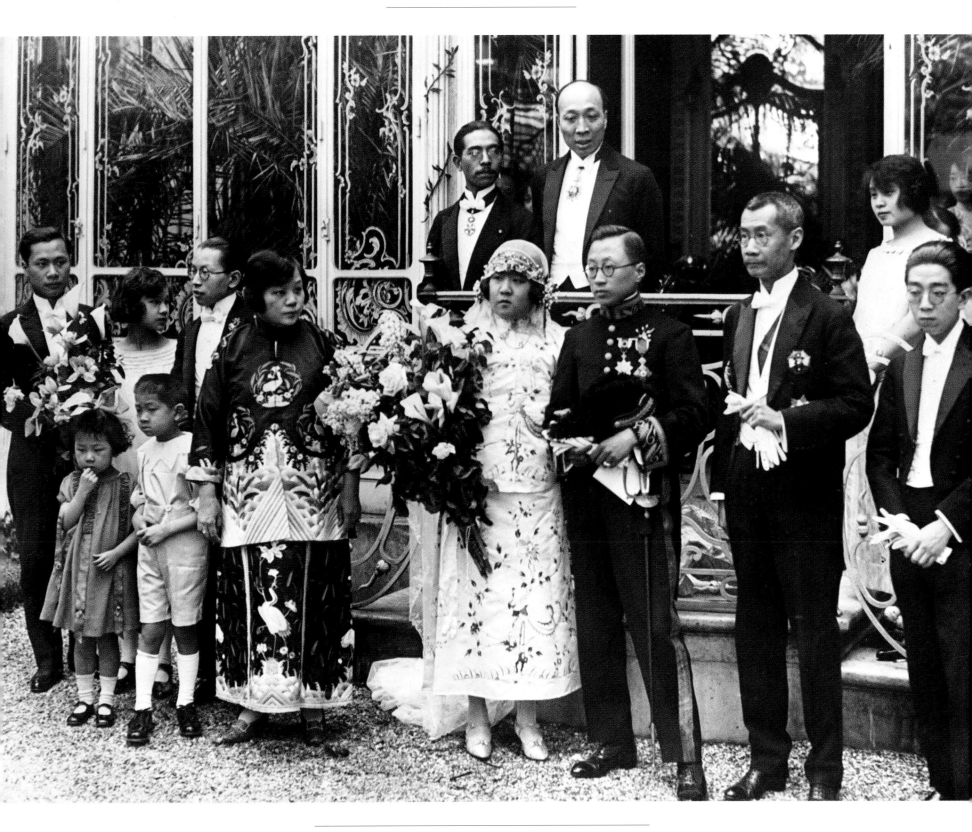

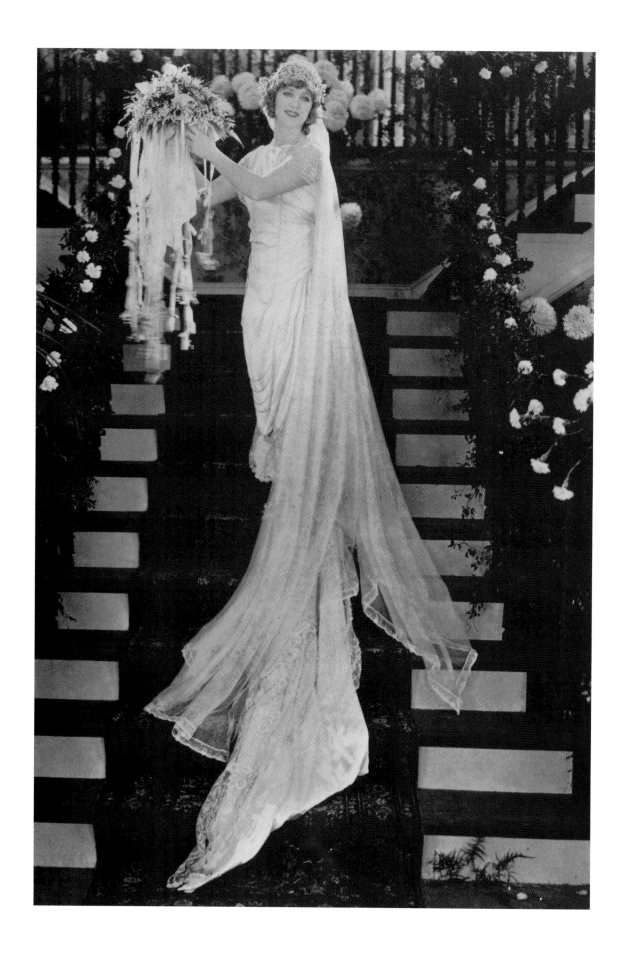

MEG LOOKED VERY LIKE A ROSE HERSELF;

FOR ALL THAT WAS BEST AND SWEETEST IN HEART AND SOUL,

MARRIAGE THAT DOES THE HEARTS AND WILLS UNITE

IS THE BEST STATE OF PLEASURE AND DELIGHT.

Thomas Shadwell, EPSOM WELLS *(1672).*

And if your hearts are bound together by love;

if both are yielding and true, if both cultivate the spirit

of meekness, forbearance, and kindness, you will be

blessed in your home and in the journey of life.

MATTHEW HALE (1609–76).

Silent-screen actress Mary Pickford wearing a wedding dress, c. 1925.

In marriage do thou be w i s e : prefer the person before money,

virtue before beauty, the mind before the body;

then thou hast a wife, a friend, a companion, a second self.

WILLIAM PENN, *SOME FRUITS OF SOLITUDE*, 1.100 (1693).

BEAUTY IS THE LOVER'S GIFT.

William Congreve, THE WAY OF THE WORLD *(1700).*

Never m a r r y but for love;

but see that thou lovest what is lovely.

WILLIAM PENN (1644–1718).

Pipers serenade a Scots wedding at the Brompton Oratory, London, 1926.

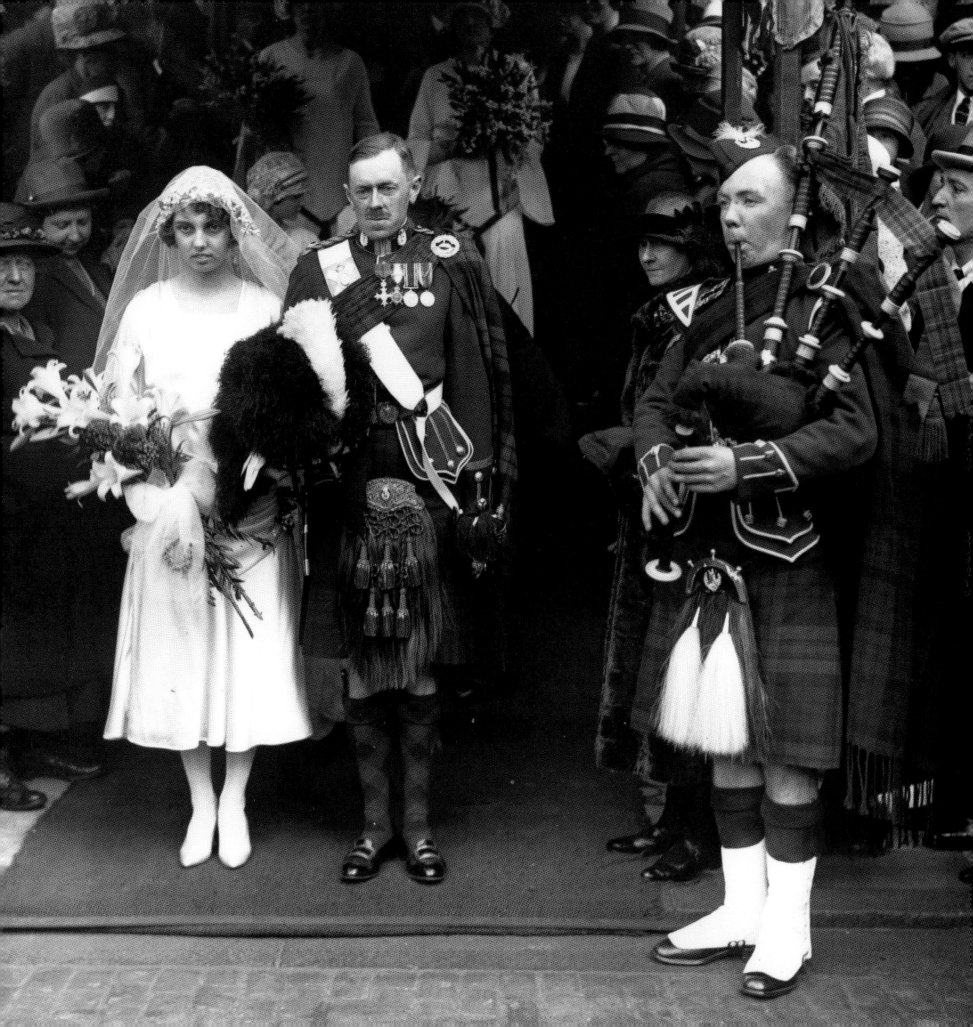

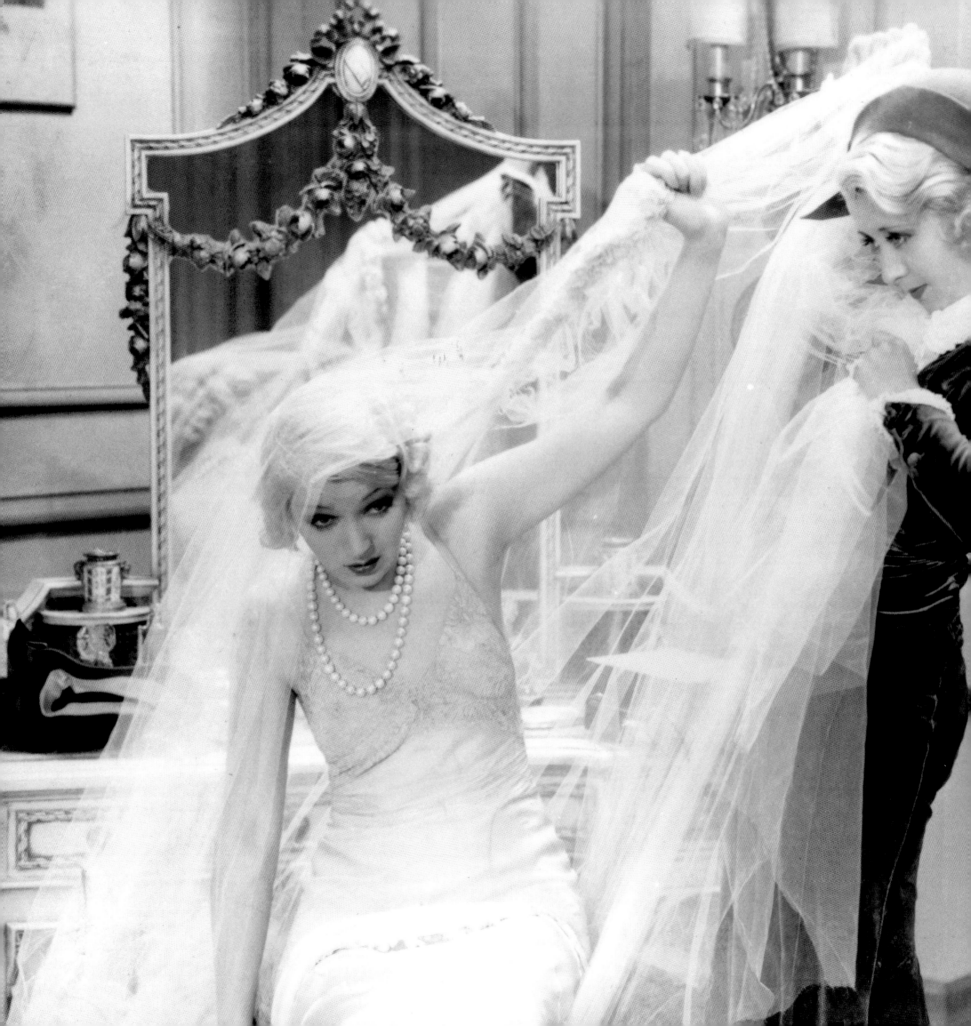

A happy marriage has in it all the pleasures

of a friendship, all the enjoyments of sense and reason,

and indeed, all the sweets of life.

JOSEPH ADDISON (1672–1719).

WE SHOULD MARRY TO PLEASE

OURSELVES, NOT OTHER PEOPLE.

Isaac Bickerstaffe (1733–1808).

You, that are going to be married,

think things can never be done too fast;

but we, that are old, and know what we are about,

must elope methodically, madam.

OLIVER GOLDSMITH, *THE GOOD-NATURED MAN*, ACT 2 (1768).

American actress Joan Blondell (1900–79) struggles with a veil in a scene from a 1930s movie.

ITIS NOT FROM REASON AND PRUDENCE THAT PEOPLE MARRY,

BUT FROM INCLINATION.

Samuel Johnson, quoted in James Boswell's LIFE OF SAMUEL JOHNSON *(1791), October 26, 1769.*

There's nothing half so sweet in life

As love's young dream.

Thomas Moore,
"Love's Young Dream,"
IRISH MELODIES
(1807–35).

A life without love, without the presence of the beloved,

is nothing but a mere lantern-show.

We draw out slide after slide, swiftly tiring of each,

and pushing it back to make haste for the next.

JOHANN WOLFGANG VON GOETHE, *ELECTIVE AFFINITIES*, 1809.

Prince Takamatsat and Miss K. Tokugawa in their wedding finery, Japan, February 24, 1930.

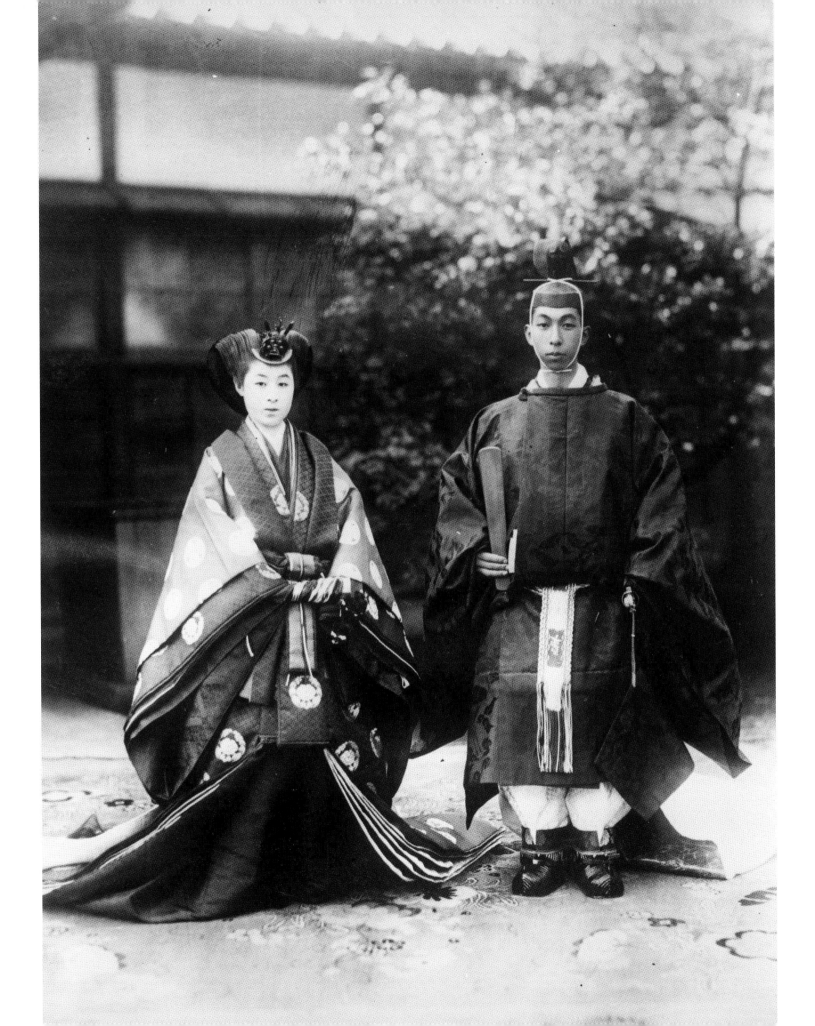

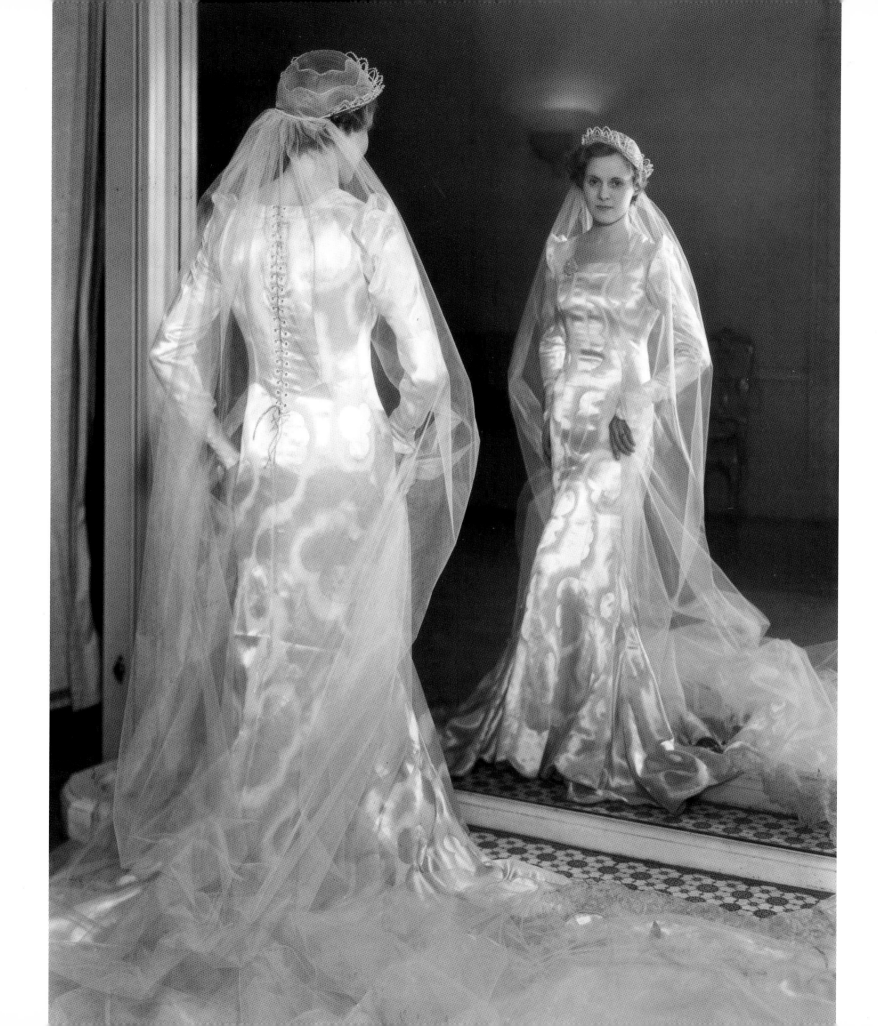

Composed on the Eve of the Marriage of a Friend in the Vale of Grasmere

What need of clamorous bells, or ribands gay,

These humble nuptials to proclaim or grace?

Angels of love, look down upon the place;

Shed on the chosen vale a sun-bright day!

Yet no proud gladness would the Bride display

Even for such promise: – serious is her face,

Modest her mein; and she, whose thoughts keep pace

With gentleness, in that becoming way

Will thank you. Faultless does the maid appear,

No disproportion in her soul, no strife:

But, when the closer view of wedded life

Hath shown that nothing human can be clear

From fragility, for that insight may the Wife

To her indulgent Lord become more dear.

WILLIAM WORDSWORTH (1812).

Actress Ann Todd (1909–93) models her wedding dress, designed by Helene Galin, November 30, 1933.

IT IS A TRUTH UNIVERSALLY ACKNOWLEDGED,

THAT A SINGLE MAN

IN POSSESSION OF A GOOD FORTUNE

MUST BE IN WANT OF A WIFE.

Jane Austin, PRIDE AND PREJUDICE *(1813).*

Without thinking highly either of men or matrimony,

marriage had always been her object;

it was the only honourable provision for well-educated

young women of small fortune,

and however uncertain of giving happiness,

must be their pleasantest preservative from want.

JANE AUSTEN, *PRIDE AND PREJUDICE* (1813).

A military wedding – the bride and groom leave a British church, c. 1933.

60

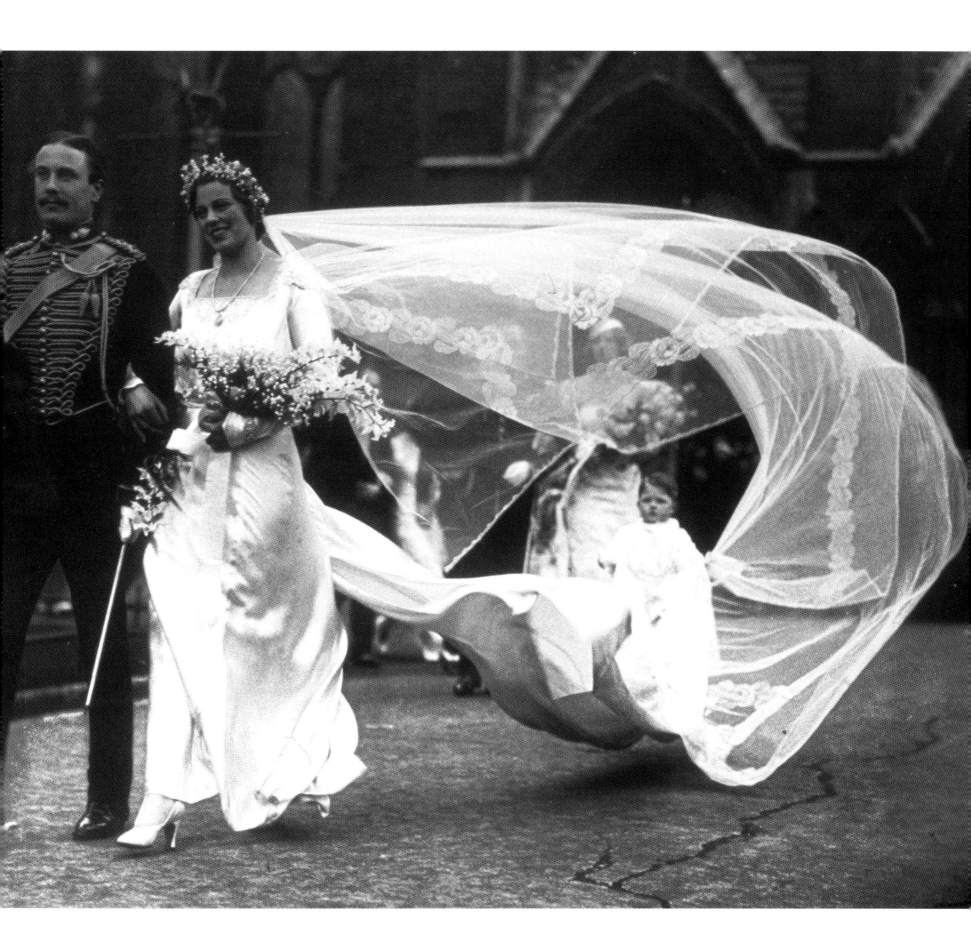

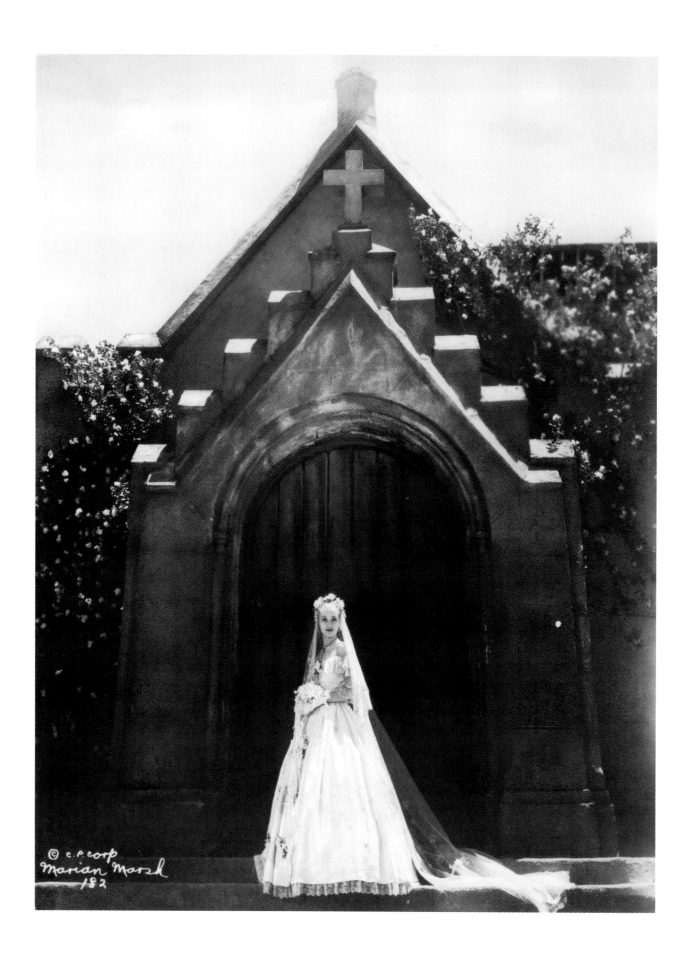

Marian Marsh
182

But [marriage's] objective source lies in the free consent of the persons, especially in their consent to make themselves one person, to renounce their natural and individual personality to this unity of one with the other. From this point of view their union is a self-restriction, but in fact it is their liberation, because in it they attain their substantive self-consciousness.

G. W. F. HEGEL,
THE PHILOSOPHY OF RIGHT (1821).

BEAUTY IS NOTHING OTHER THAN THE PROMISE OF HAPPINESS.

Stendhal, ON LOVE *(1822).*

Actress Marian Marsh waits outside the church in the movie THE BLACK ROOM, *1935.*

A daughter of the gods, divinely tall,

And most divinely fair.

ALFRED, LORD TENNYSON,
"A DREAM OF FAIR WOMEN" (1832).

AND OUR SPIRITS RUSHED TOGETHER

AT THE TOUCHING OF THE LIPS.

Alfred, Lord Tennyson, "Locksley Hall" (1842).

Beauty hath no true glass, except it be

In the sweet privacy of loving eyes.

JAMES RUSSELL LOWELL,
"A CHIPPEWA LEGEND" (1843).

A portrait of the Duke and Duchess of Windsor on their wedding day in France, June 3, 1937.

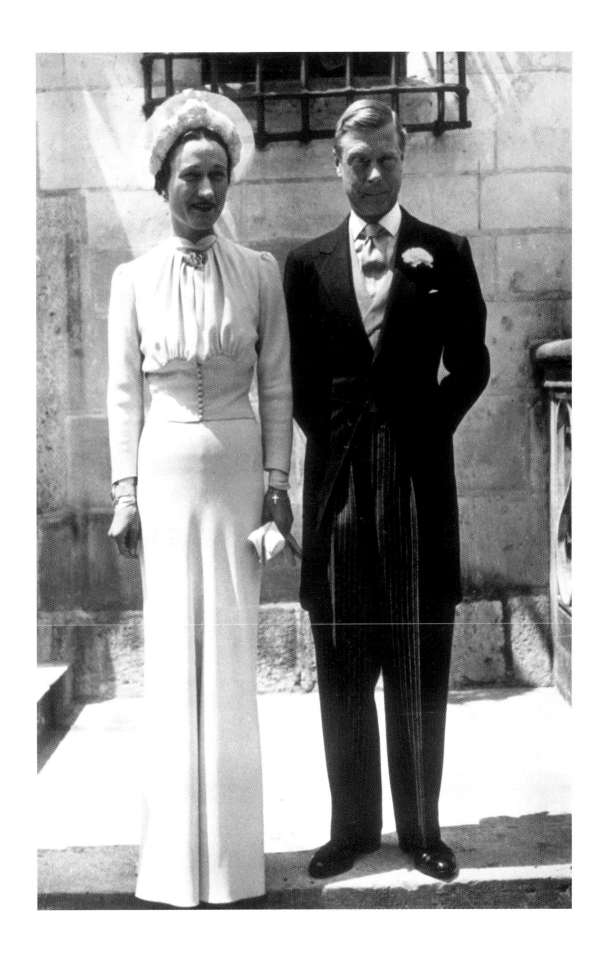

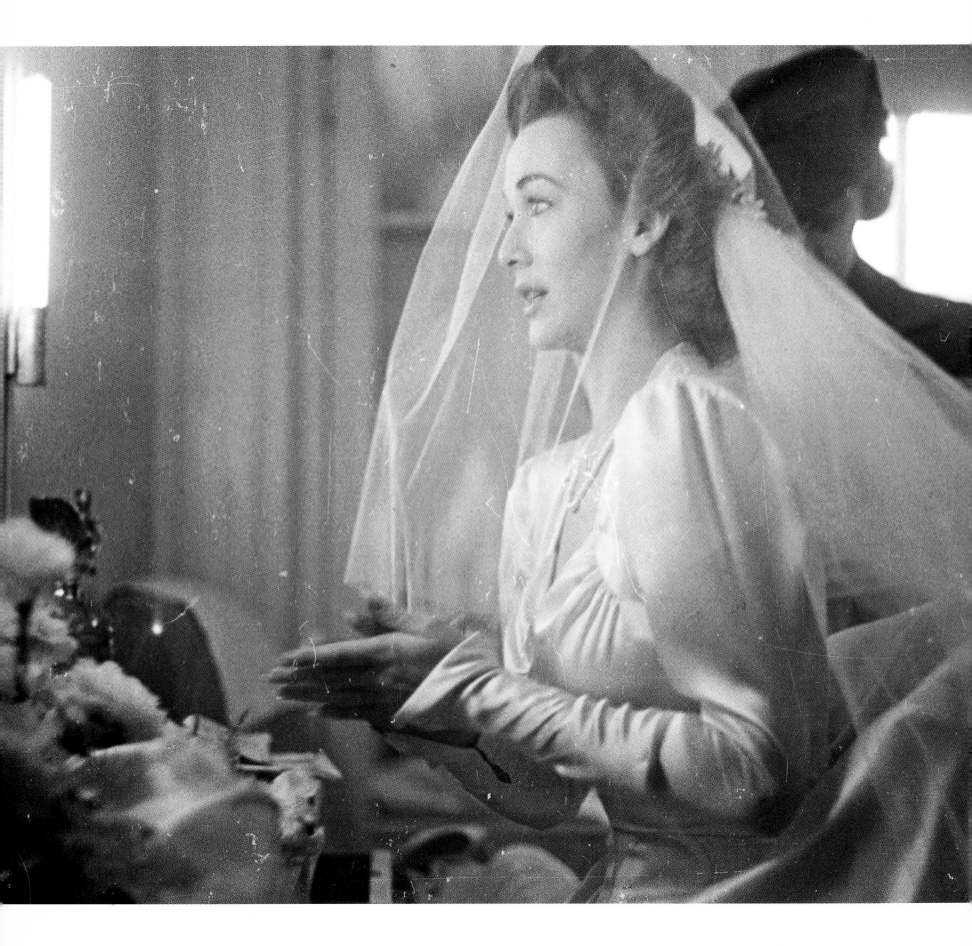

THAT IS A WISE REGULATION OF THE CHURCH

WHICH MAKES THE MARRIAGE CEREMONY BRIEF,

FOR THE INTENSITY OF THE FEELINGS IT OFTEN CREATES

WOULD FREQUENTLY BECOME TOO POWERFUL

TO BE SUPPRESSED, WERE IT UNNECESSARILY PROLONGED.

James Fenimore Cooper (1789-1851).

The things which you ought to desire in a wife are,

1. Chastity; 2. Sobriety;

3. Industry; 4. Frugality;

5. Cleanliness; 6. Knowledge of domestic affairs;

7. Good temper; 8. Beauty.

WILLIAM COBBETT,
ADVICE TO YOUNG MEN AND (INCIDENTALLY) TO YOUNG WOMEN (1829).

Carole Landis (1919-48) checks her wedding dress before marrying U.S. Army Air Force Captain Thomas Wallace in London during World War II, January 23, 1943.

Every wedding where true lovers wed,

helps on the march of universal Love.

Who are brides here shall be Love's bridesmaids

in the marriage world to come.

HERMAN MELVILLE (1819–91).

ONE SHOULD BELIEVE IN MARRIAGE

AS IN THE IMMORTALITY OF THE SOUL.

Honoré de Balzac (1799–1850).

Not the marriage of convenience, nor the marriage of reason,

but the marriage of love. All other marriage, with vows so solemn,

with intimacy so close, is but acted falsehood and varnished sin.

EDWARD ROBERT BULWER (1831–91).

A little girl stares into a department store window at a bridal gown, 1945.

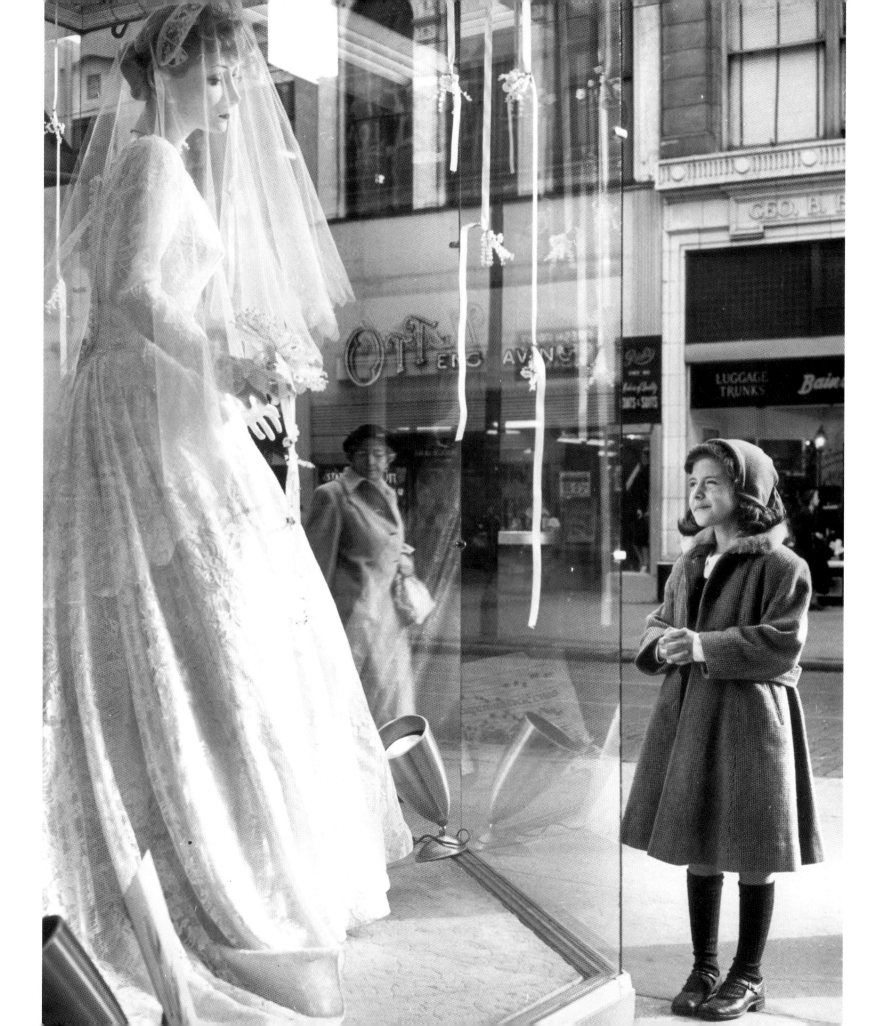

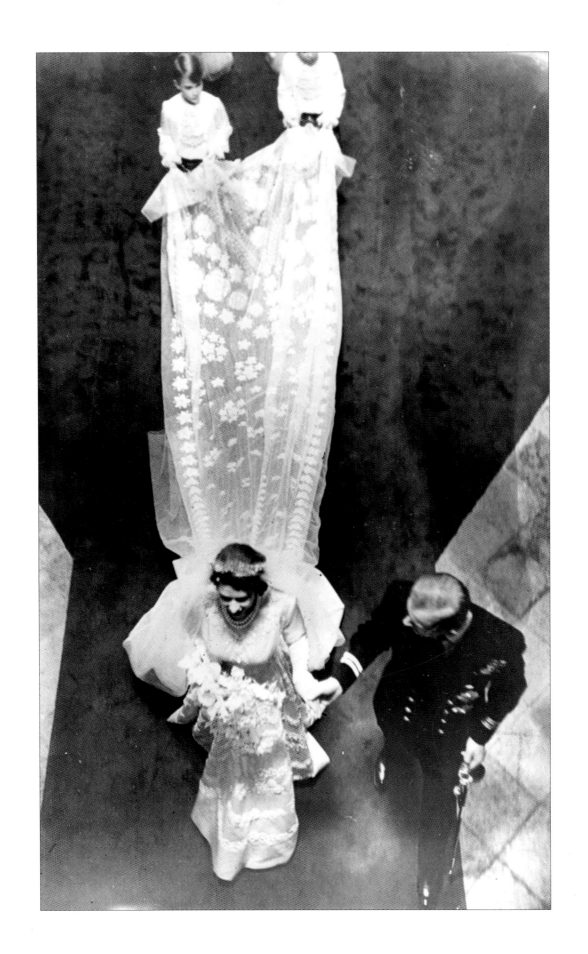

He rose, and with a stride reached me.

"My bride is here," he said, again drawing me to him,

"because my equal is here, and my likeness. Jane, will you marry me?"

CHARLOTTE BRONTË,
JANE EYRE (1847).

TO BE YOUR WIFE IS, FOR ME,

TO BE AS HAPPY AS I CAN BE ON EARTH.

Charlotte Brontë, JANE EYRE *(1847).*

Reader, I married him.

CHARLOTTE BRONTË,
JANE EYRE (1847).

*Princess Elizabeth and Prince Philip, Duke of Edinburgh, leave Westminster Abbey
after their wedding ceremony, November 20, 1947.*

71

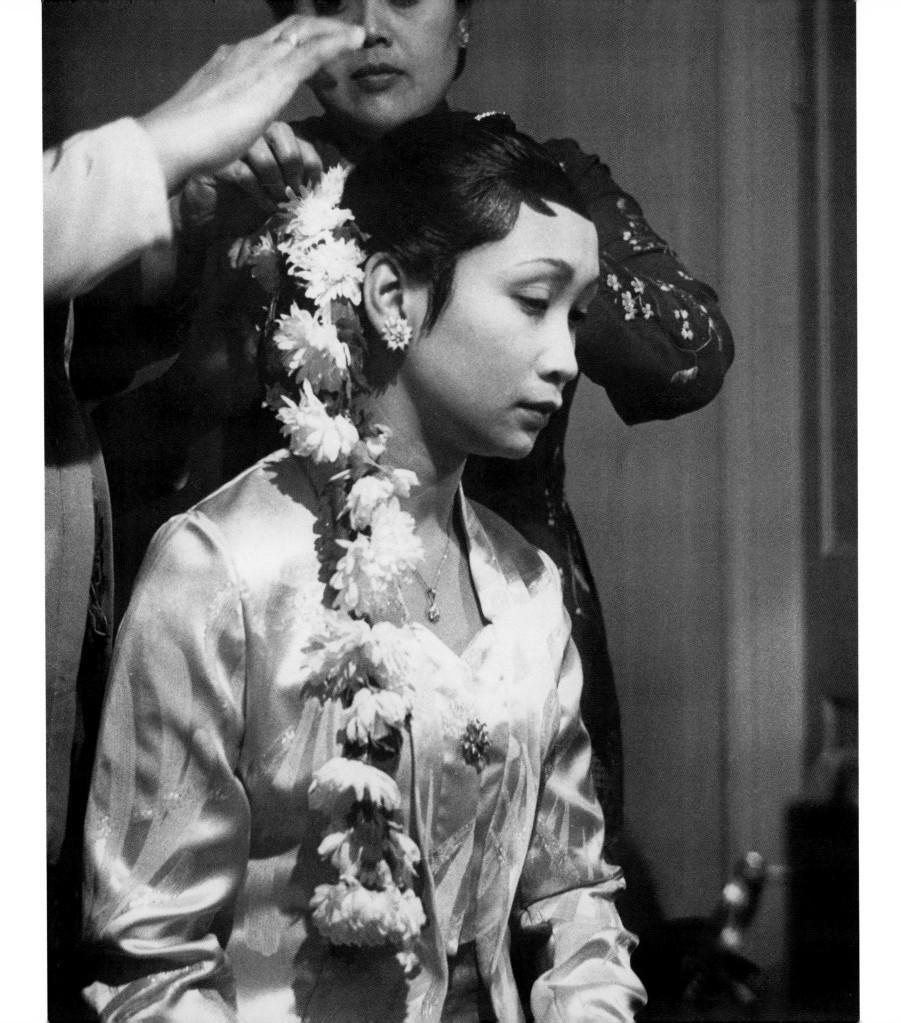

Nuptial Sleep

At length their long kiss severed, with sweet smart:

And as the last slow sudden drops are shed

From sparkling eaves when all the storm has fled,

So singly flagged the pulses of each heart.

Their bosoms sundered, with the opening start

Of married flowers to either side outspread

From the knit stem; yet still their mouths, burnt red,

Fawned on each other where they lay apart.

Sleep sank them lower than the tide of dreams,

And their dream watched them sink, and slid away.

Slowly their souls swam up again, through gleams

Of watered light and dull drowned waifs of day;

Till from some wonder of new woods and streams

He woke, and wondered more: for there she lay.

DANTE GABRIEL ROSSETTI (1828–82).

Indonesian bride Miss Tati Widari has her hair dressed, London, 1951.

This is the question

Marry Not Marry

Children – (if it please God) – constant companion,

who will feel interested in one (a friend in old age) –

object to be beloved and played with – better than a dog

anyhow – Home, and someone to take care of the house –

Classics of Music and female Chit Chat –

These things good for one's health –

CHARLES DARWIN, 1838.

THE MOTHER WEEPS

AT THAT WHITE FUNERAL OF THE SINGLE LIFE,

HER MAIDEN DAUGHTER'S MARRIAGE; AND HER TEARS

ARE HALF OF PLEASURE, HALF OF PAIN.

Alfred, Lord Tennyson, "To H.R.H. Princess Beatrice" (1843).

Bride Mary Clegg looks in the mirror before leaving for church, 1954.

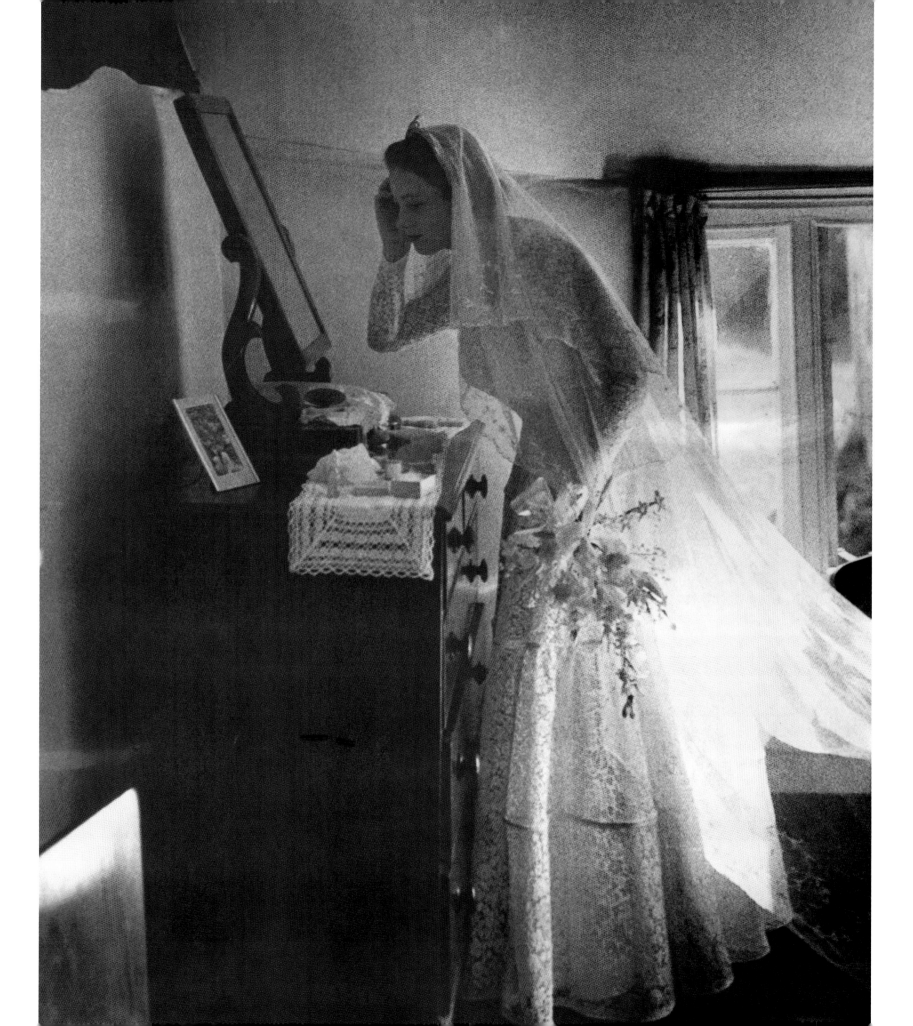

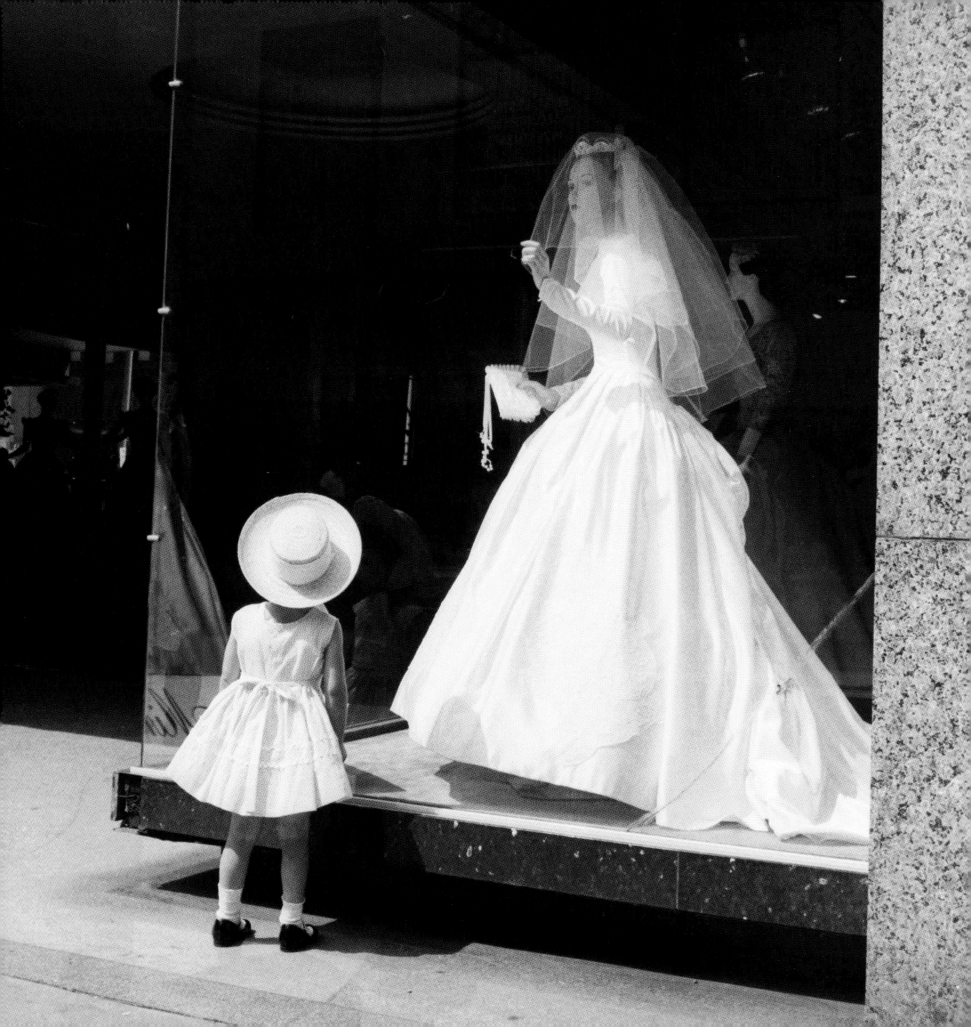

Hear the mellow wedding bells –
Golden bells!
What a world of happiness their harmony foretells!
Through the balmy air of night
How they ring out their delight! –
From the molten-golden notes,
And all in tune,
What a liquid ditty floats
To the turtle-dove that listens, while she gloats
On the moon!
Oh, from the sounding cells,
What a gush of euphony voluminously wells!
How it swells!
How it dwells
On the Future! – how it tells
Of the rapture that impels
To the swinging and the ringing
Of the bells, bells, bells, –
Of the bells, bells, bells,
To the rhyming and the chiming of the bells!

EDGAR ALLAN POE (1809–49), FROM "THE BELLS."

A department-store bride fascinates a little girl, c. 1955.

LET MEN TREMBLE TO WIN THE HAND OF WOMAN

UNLESS THY WIN ALONG WITH IT

THE UTMOST PASSION OF HER HEART!

Nathaniel Hawthorne, THE SCARLET LETTER *(1850).*

In true marriage lies

Nor equal, nor unequal. Each fulfils

Defect in each, and always thought in thought,

Purpose in purpose, will in will, they grow,

The single pure and perfect animal,

The two-celled heart beating, with one full strike,

Life.

ALFRED, LORD TENNYSON,
"THE PRINCESS; A MEDLEY," 7 (1851).

A Norman Hartnell wedding dress, c. 1957.

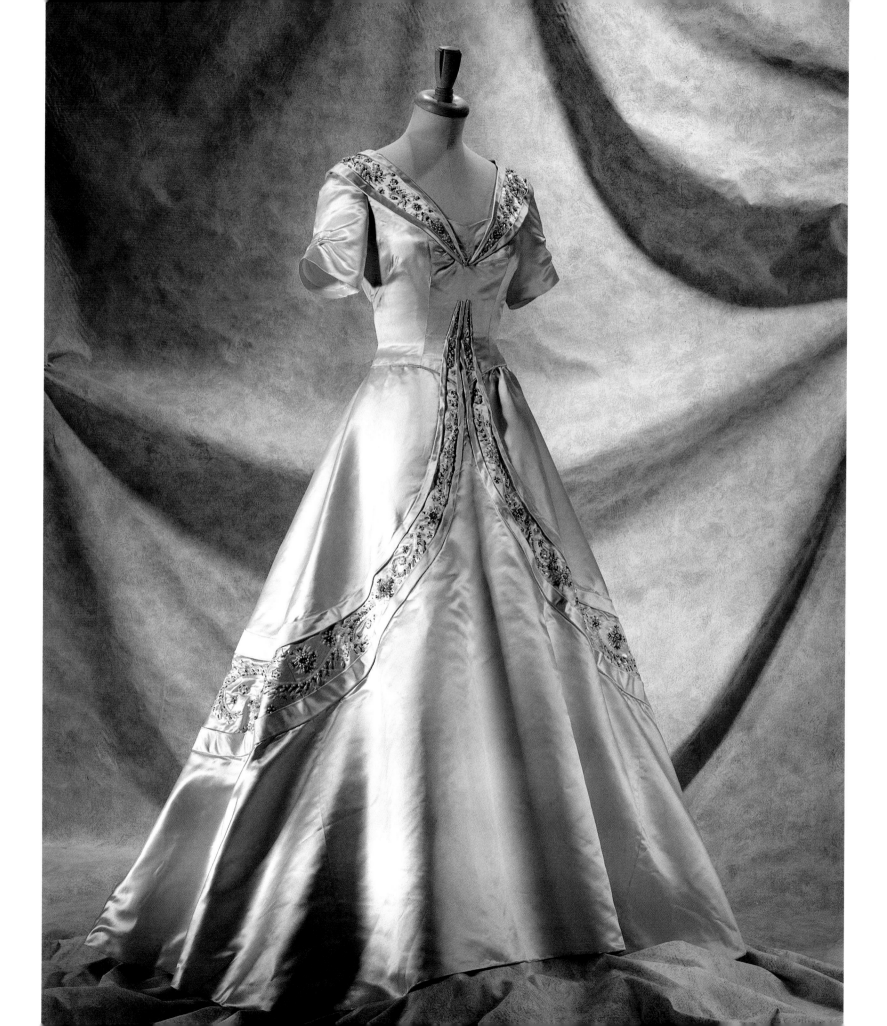

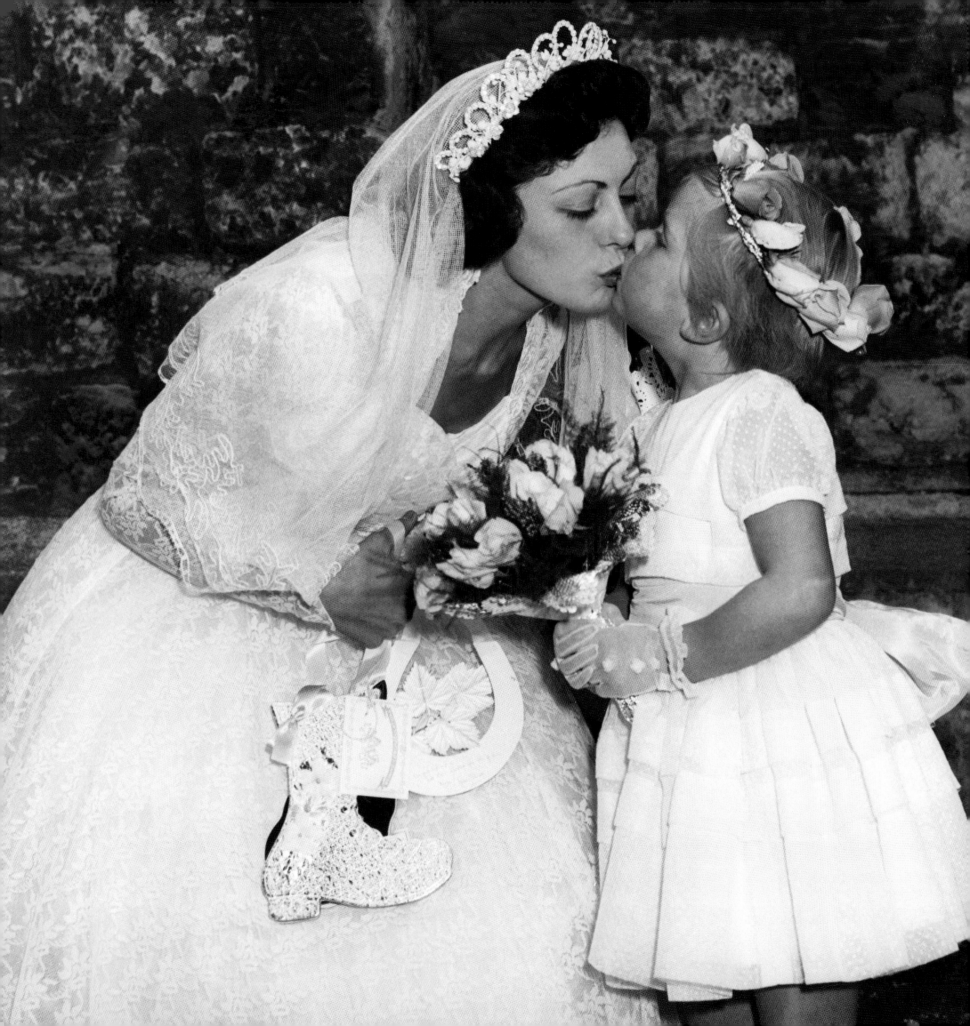

Only – but this is rare –

When a belovèd hand is laid in ours,

When, jaded with the rush and glare

Of the interminable hours,

Our eyes can in another's eyes read clear,

When our world-deafened ear

Is by the tones of a loved voice caressed –

A bolt is shot back somewhere in our breast,

And a lost pulse of feeling stirs again.

The eye sinks inward, and the heart lies plain,

And what we mean, we say, and what we would, we know.

Matthew Arnold, "The Buried Life" (1852).

Bride and bridesmaid, September 26, 1957.

WHEN I GIVE I GIVE MYSELF.

Walt Whitman, "Song of Myself," LEAVES OF GRASS *(1855–92).*

The voice that breathed o'er Eden,

That earliest wedding-day,

The primal marriage blessing,

It hath not passed away.

JOHN KEBLE, "HOLY MATRIMONY" (1857).

Southern belle, Mrs. William Ferguson, in her wedding dress at Oak Alley, Mississippi, 1957.

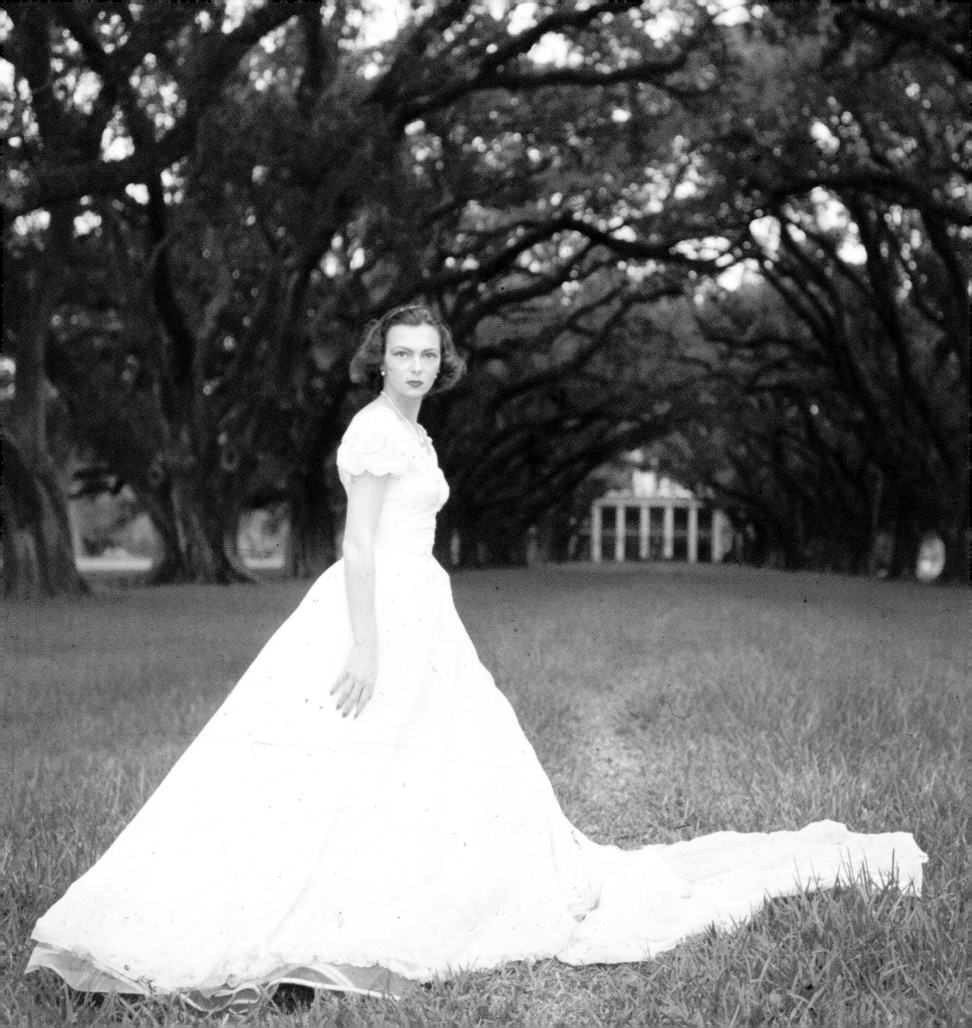

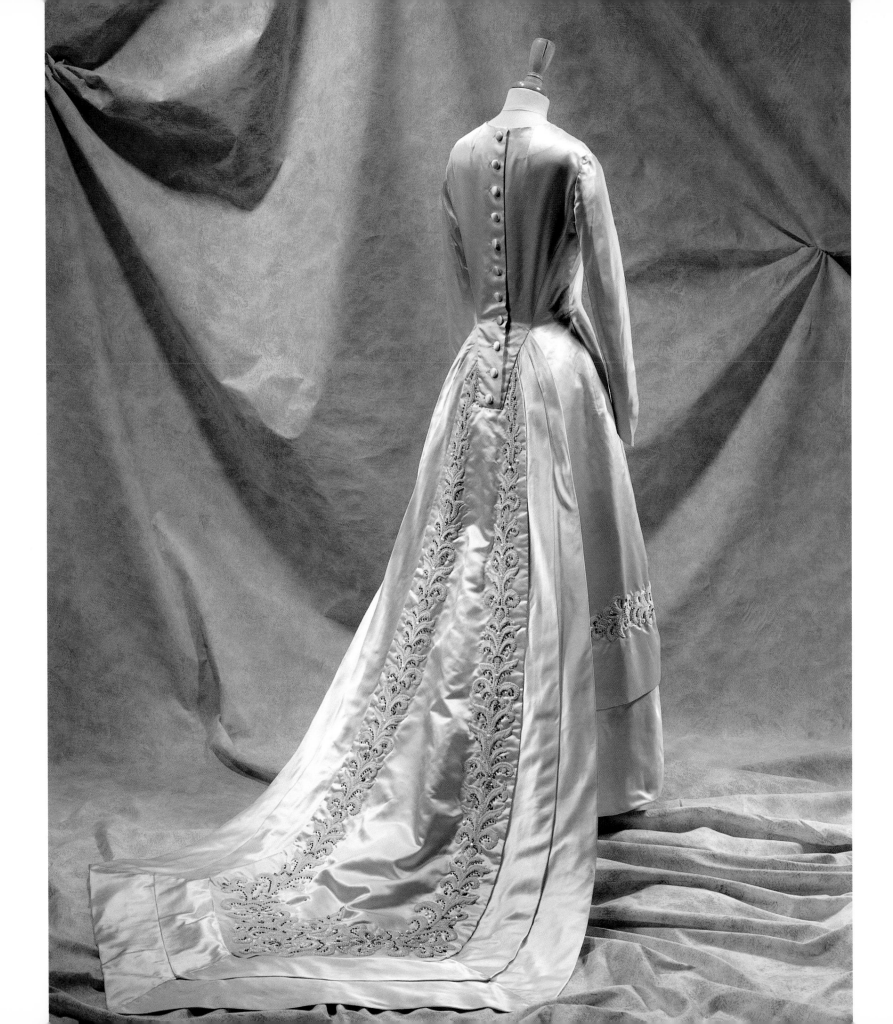

To love one maiden only, cleave to her,

And worship her by years of noble deeds,

Until they won her; for indeed I knew

Of no more subtle master under heaven

Than is the maiden passion for a maid,

Not only to keep down the base in man,

But teach high thought, and amiable words

And courtliness, and the desire of fame,

And love of truth, and all that makes a man.

ALFRED, LORD TENNYSON, *IDYLLS OF THE KING*, "GUINEVERE" (1859).

Cream beaded satin wedding dress, c. 1961.

At the Wedding March

God with honor hang your head,

 Groom, and grace you, bride, your bed

 With lissom scions, sweet scions,

Out of hallowed bodies bred.

 Each be other's comfort kind:

 Deep, deeper than divined,

Divine charity, dear charity,

 Fast you ever, fast bind.

 Then let the March tread our ears:

 I to him turn with tears

 Who to wedlock, his wonder wedlock,

 Deals triumph and immortal years.

GERARD MANLEY HOPKINS (1844–89).

Bridal train, December 13, 1962.

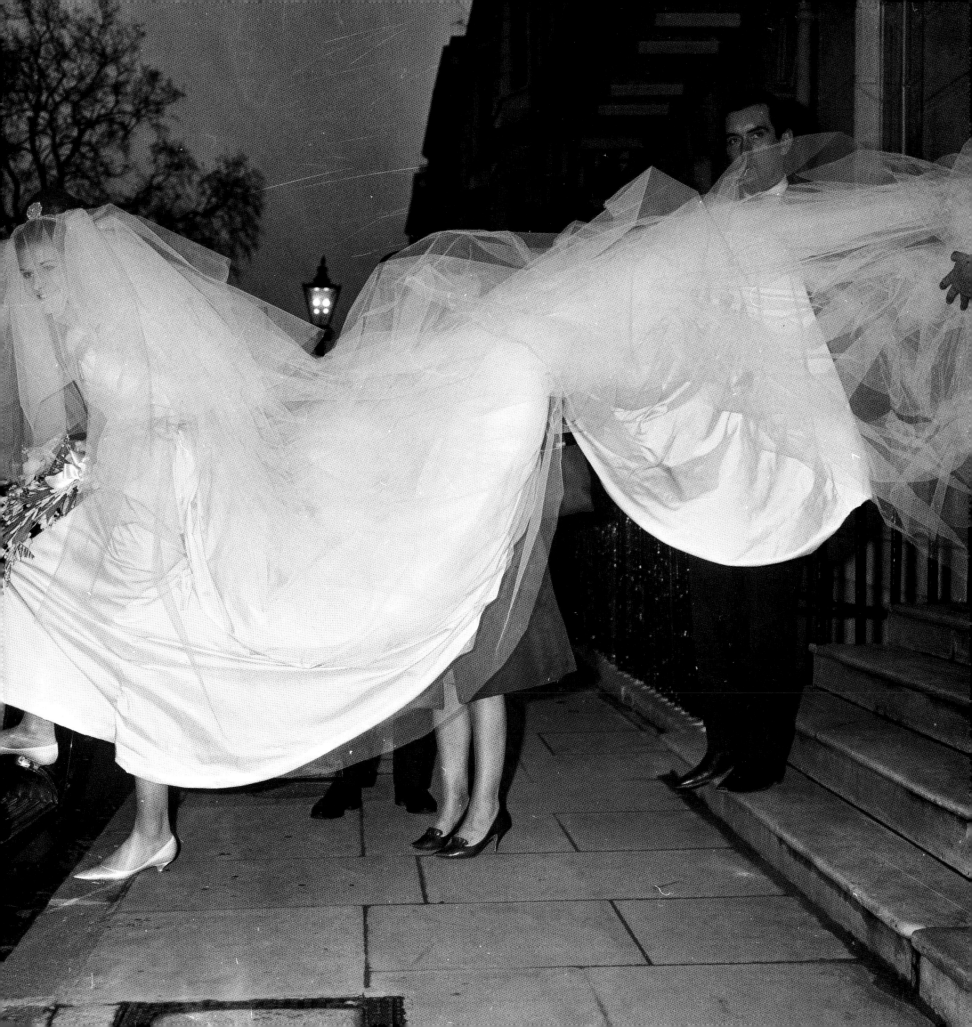

Happily the sunshine fell more warmly than usual

on the lilac tufts on the morning that Eppie was married,

for her dress was a very light one. She had often thought,

though with a feeling of renunciation, that the perfection

of a wedding dress would be a white cotton, with the tiniest pink sprig

at intervals; so that when Mrs Godfrey Cass begged to provide one,

and asked Eppie to choose what it should be,

previous meditation had enabled her to give a decided answer at once.

Seen at a distance as she walked across the churchyard

and down the village, she seemed to be attired in pure white,

and her hair looked like the dash of gold on a lily.

One hand was on her husband's arm and with the other

she clasped the hand of her father Silas.

GEORGE ELIOT, *SILAS MARNER* (1861).

A Japanese bride's paper wedding dress, March 30, 1964.

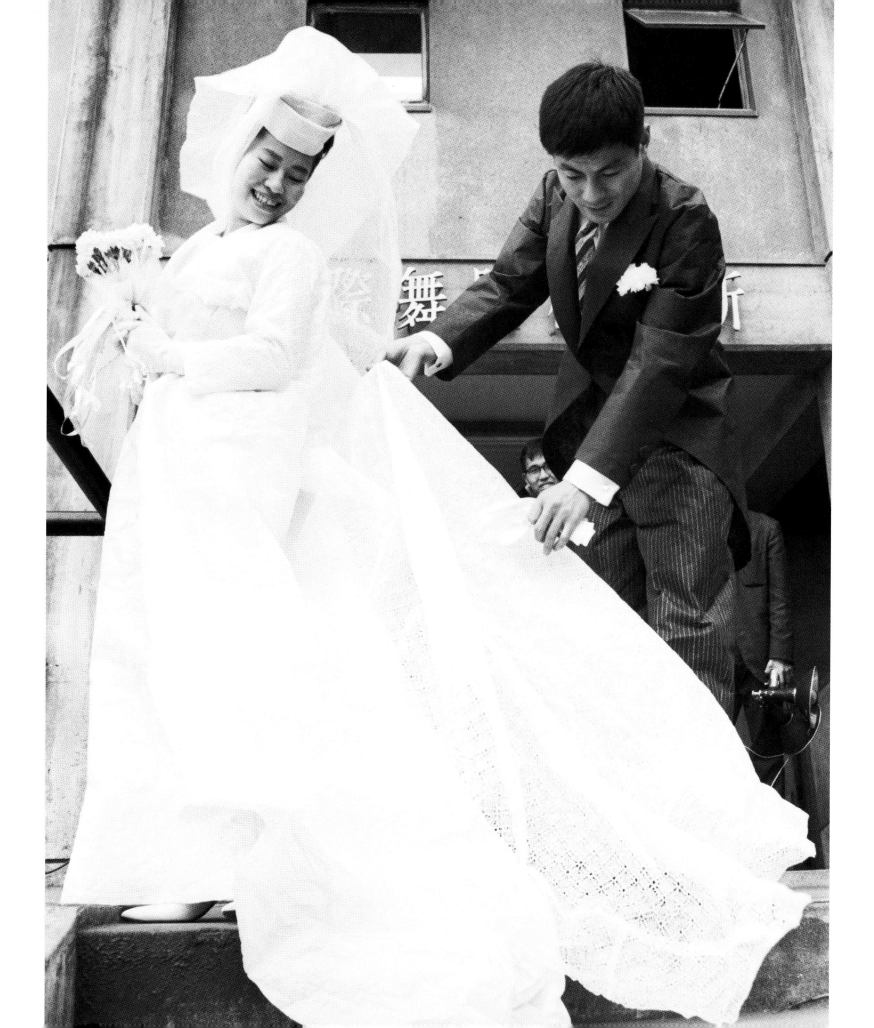

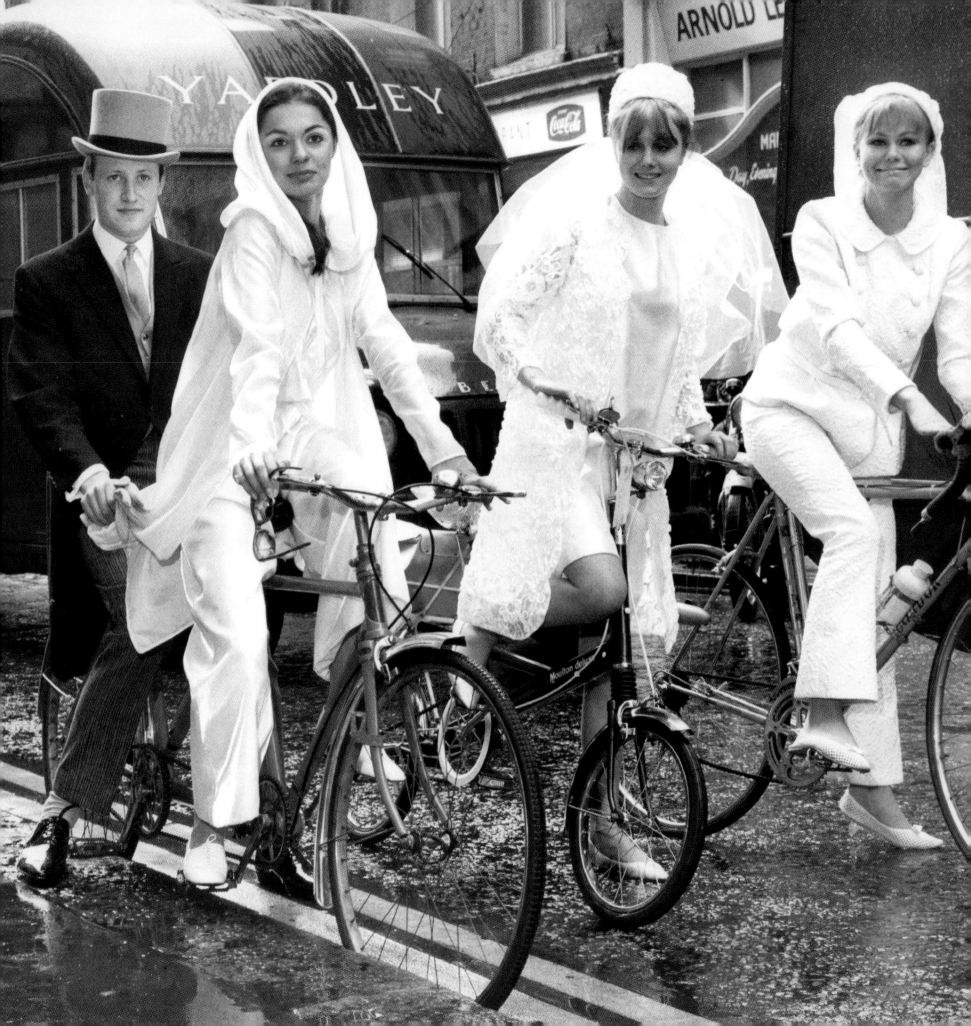

The supreme happiness of life

is the conviction that we are loved.

Victor Hugo, "Fantine," LES MISÉRABLES *(1862).*

Grow old along with me!

The best is yet to be,

The last of life, for which the first was made:

Our times are in His hand

Who saith, "A whole I planned,

Youth shows but half; trust God: see all nor be afraid!"

ROBERT BROWNING. "RABBI BEN EZRA" (1864).

The swinging sixties – model brides on bikes, April 6, 1966.

What marriage may be

in the case of two persons of cultivated faculties,

identical in opinions and purposes,

between whom there exists that best kind of equality,

similarity of powers and capacities with reciprocal superiority in them –

so that each can enjoy the luxury

of looking up to the other, and can have alternately the pleasure

of leading and of being led in the path of development –

I will not attempt to describe.

To those who can conceive it, there is no need;

to those who cannot, it would appear the dream of an enthusiast.

JOHN STUART MILL, *SUBJECTION OF WOMEN* (1869).

Actress Meredith MacRae and Greg Mulleavey after their outdoor wedding, Pacific Palisades, California, April 19, 1969.

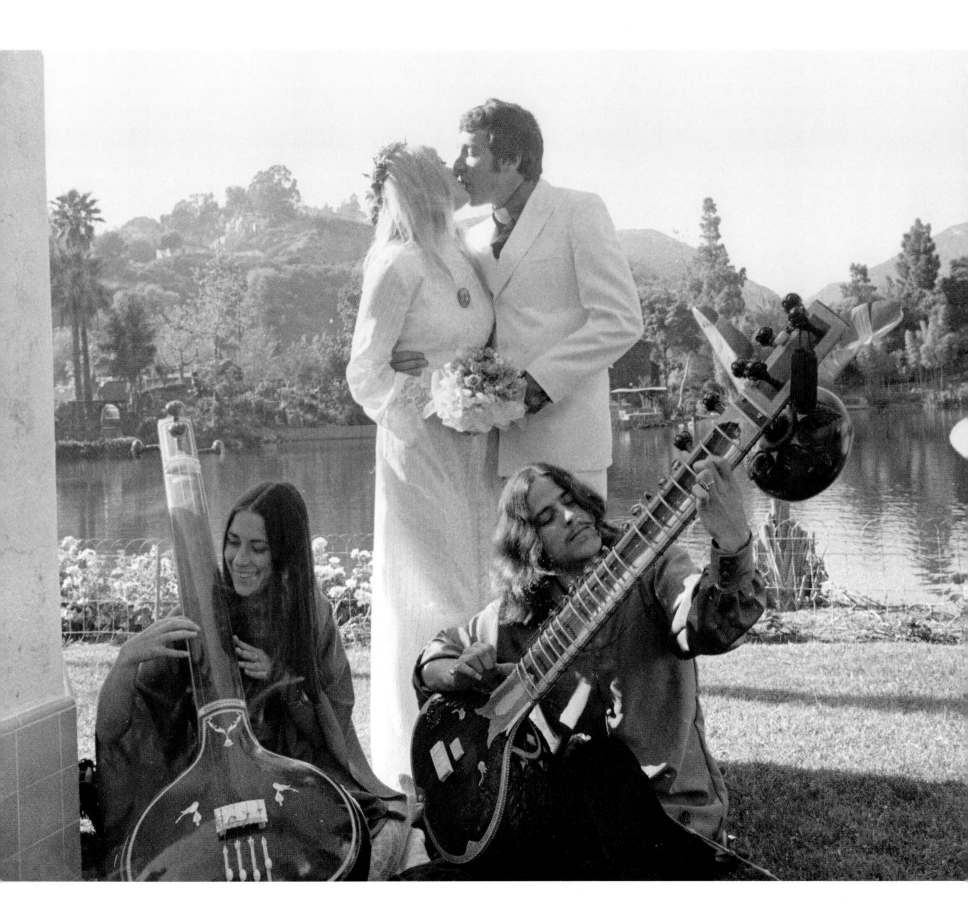

A MARRIAGE IS NO AMUSEMENT
BUT A SOLEMN ACT,
AND GENERALLY A SAD ONE.

Queen Victoria (1819–1901).

Marriage,

which has been the bourne of so many narratives,

is still a great beginning, as it was to Adam and Eve,

who kept their honeymoon in Eden, but had their first little

one among the thorns and thistles of the wilderness.

It is still the beginning of the home epic – the gradual conquest

or irremediable loss of that complete union which makes

the advancing years a climax, and age the harvest

of sweet memories in common.

GEORGE ELIOT, *MIDDLEMARCH* (1871).

Unification Church mass wedding of 790 couples in Seoul, South Korea, October 21, 1970.

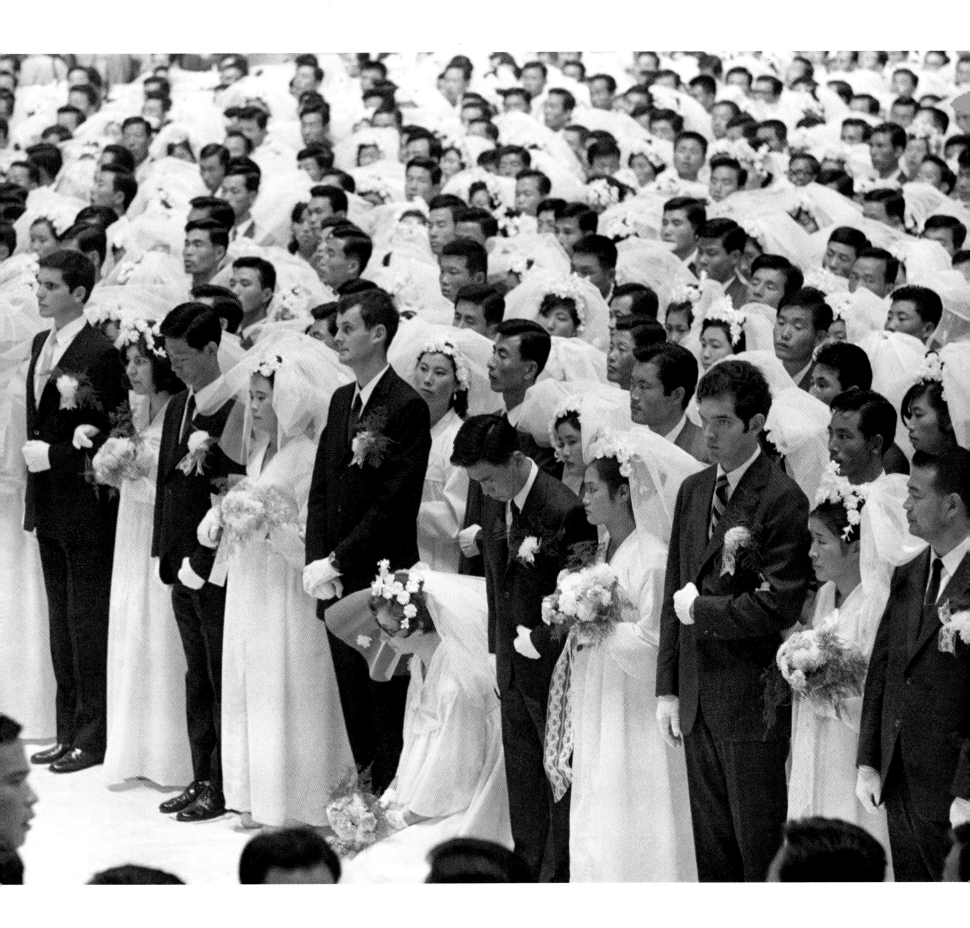

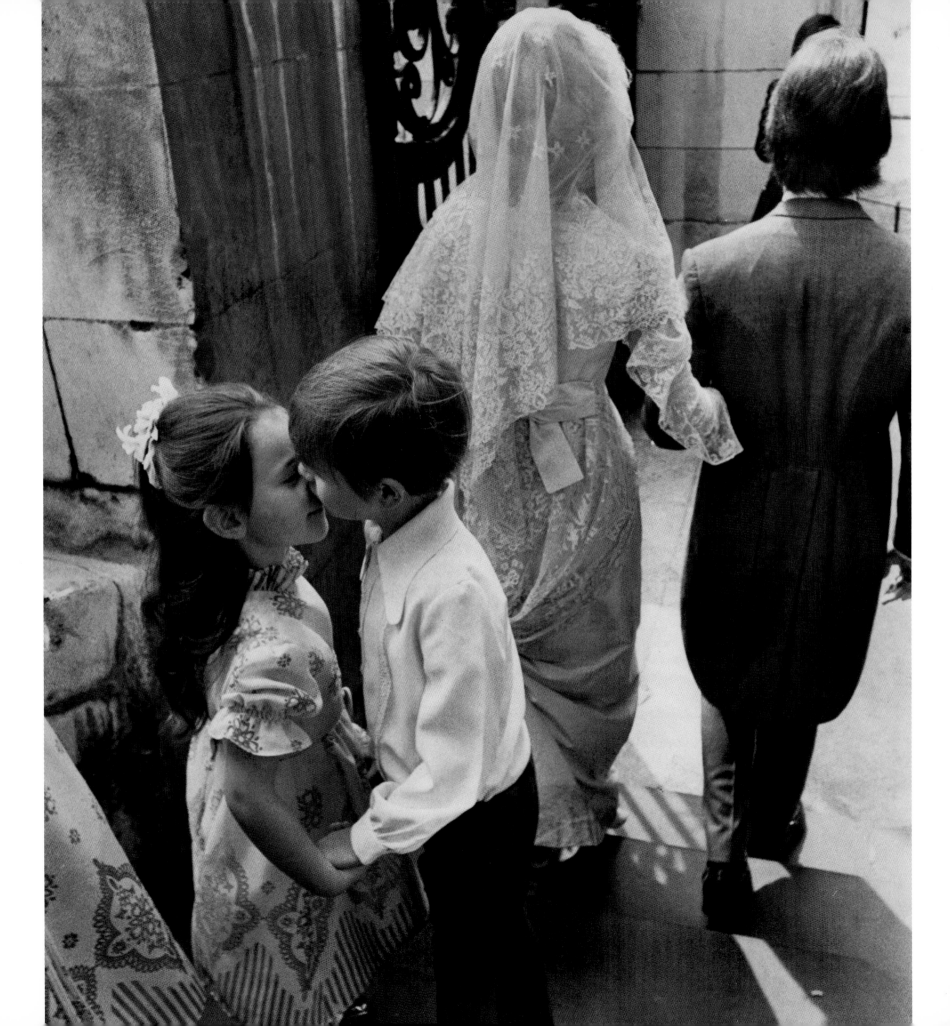

He sat down and wrote out a long sentence. She understood it all and without asking him whether she had it right took the chalk and replied immediately.

For a long time he could not understand what she had written, and he kept looking into her eyes. He was numb with happiness. He could not fill in the words she meant at all, but in her lovely eyes, radiant with happiness, he understood everything he had to know. He wrote down three letters; but before he had even finished writing she had already read it under his hand; she had finished it herself, and written down the answer: "Yes."

COUNT LEO TOLSTOY.
ANNA KARENINA (1873–76).

THE ONLY THING THAT CAN HALLOW MARRIAGE IS LOVE,

AND THE ONLY GENUINE MARRIAGE IS THAT WHICH IS HALLOWED BY LOVE.

Count Leo Tolstoy (1828–1910).

A page and bridesmaid kiss on the steps of St. Paul's Cathedral, London, during the 1970s.

MEG LOOKED VERY LIKE A ROSE HERSELF,

FOR ALL THAT WAS BEST AND SWEETEST IN HEART AND SOUL

SEEMED TO BLOOM INTO HER FACE THAT DAY,

MAKING IT FAIR AND TENDER,

WITH A CHARM MORE BEAUTIFUL THAN BEAUTY.

NEITHER SILK, LACE, NOR ORANGE FLOWERS WOULD SHE HAVE.

"I DON'T WANT TO LOOK STRANGE OR FIXED UP, TODAY," SHE SAID,

"I DON'T WANT A FASHIONABLE WEDDING,

BUT ONLY THOSE ABOUT ME WHOM I LOVE

AND TO THEM I WISH TO LOOK AND BE MY FAMILIAR SELF."

Louisa May Alcott (1832–88), GOOD WIVES.

Cajun newly-weds in a carriage, Abbeville, Louisiana, c. 1976.

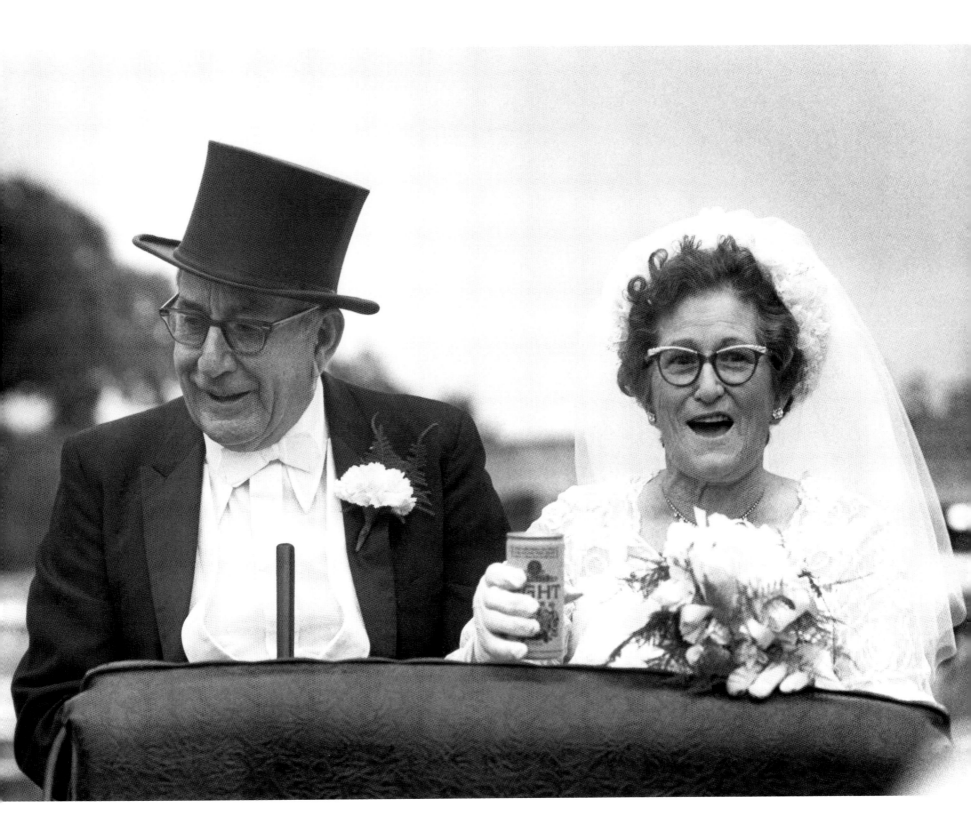

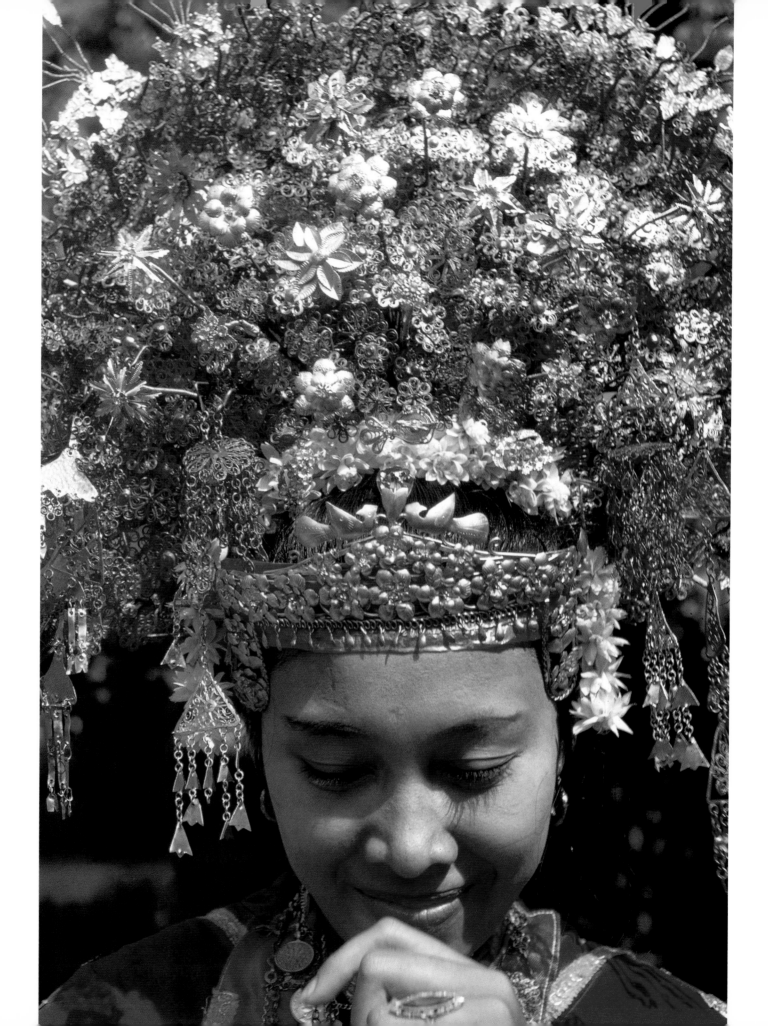

A Proposal

"Life is all very pleasant for you,"

Said fair Chloe one night at a ball,

"You men, you have plenty to do,

We poor women have nothing at all."

I urged her to paint or to play

To write or to knit or to sew,

To visit the poor and to pray,

To each and to all she said, "No."

At last I exclaimed in despair,

"If you really are anxious to be

Of some use, and for none of these care,

You must marry! Why not marry me?"

LORD ROBERT CECIL (1888).

Sumatran bride in floral headdress, 1980s.

They had exchanged VOWS and tokens,

sealed their rich compact, solemnised,

so far as breathed words and murmured sounds and lighted eyes

and clasped hands could do it,

their agreement to belong only,

and to belong tremendously, to each other.

HENRY JAMES, *THE WINGS OF THE DOVE* (1902).

WHEN A WOMAN GETS MARRIED

IT'S LIKE JUMPING INTO A HOLE IN THE ICE

IN THE MIDDLE OF WINTER:

YOU DO IT ONCE,

AND YOU REMEMBER IT THE REST OF YOUR DAYS.

Maxim Gorky, THE LOWER DEPTHS *(1903)*.

Sketch by Elizabeth Emmanuel for the wedding dress worn by Lady Diana Spencer for her marriage to Prince Charles, July 29, 1981.

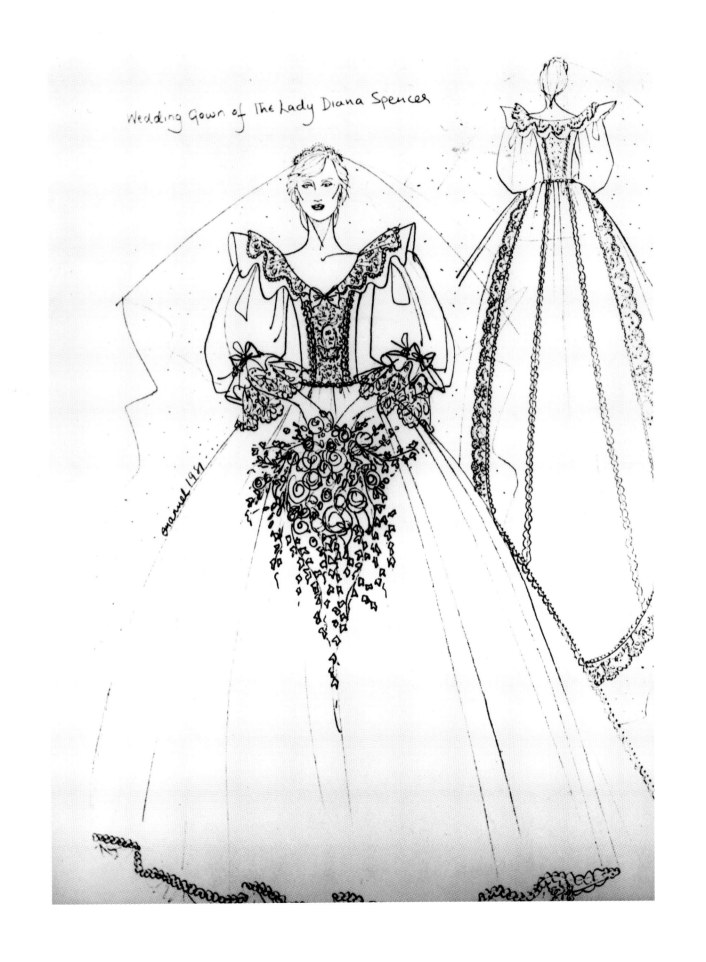

Wedding Gown of the Lady Diana Spencer

WHEN ONE LOVES SOMEBODY, EVERYTHING IS CLEAR —

WHERE TO GO, WHAT TO DO —

IT ALL TAKES CARE OF ITSELF

AND ONE DOESN'T HAVE TO ASK ANYBODY ABOUT ANYTHING.

Maxim Gorky, THE ZYKOVS *(1914).*

Now and then she was so bewildered by discoveries

that she came to wonder why she had married him, and why people do marry — really!

The fact was that she had married him for the look in his eyes.

It was a sad look, and beyond that it could not be described.

Also, a little, she had married him for his bright untidy hair,

and for that short oblique shake of the head which, with him,

meant a greeting or an affirmative.

ARNOLD BENNETT, *THESE TWAIN* (1915).

The day itself, July 29, 1981, Lady Diana on St. Paul's Cathedral steps.

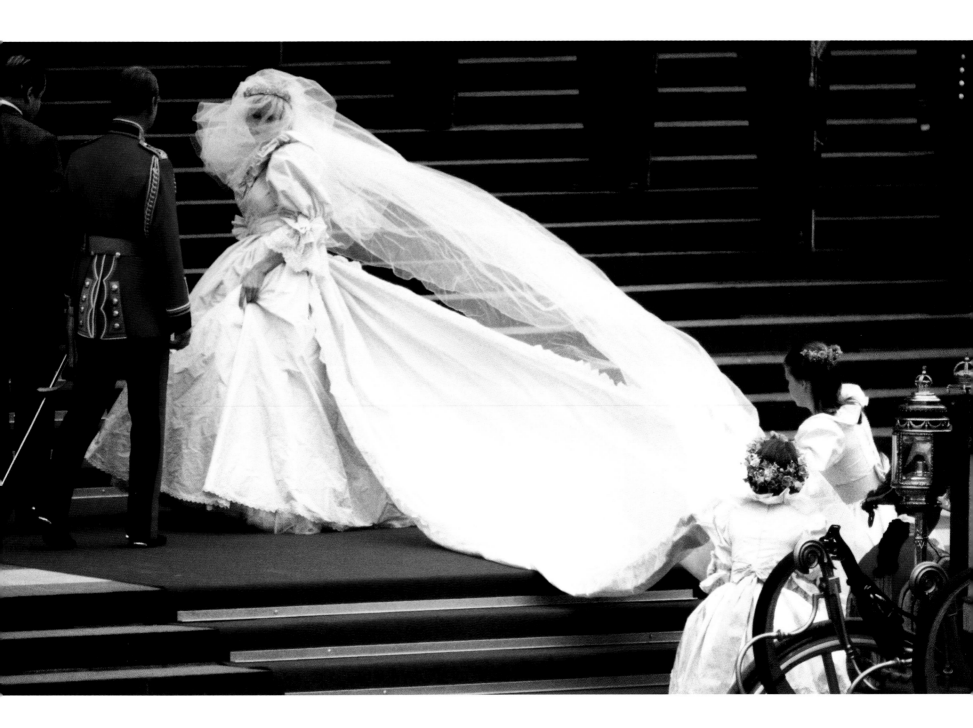

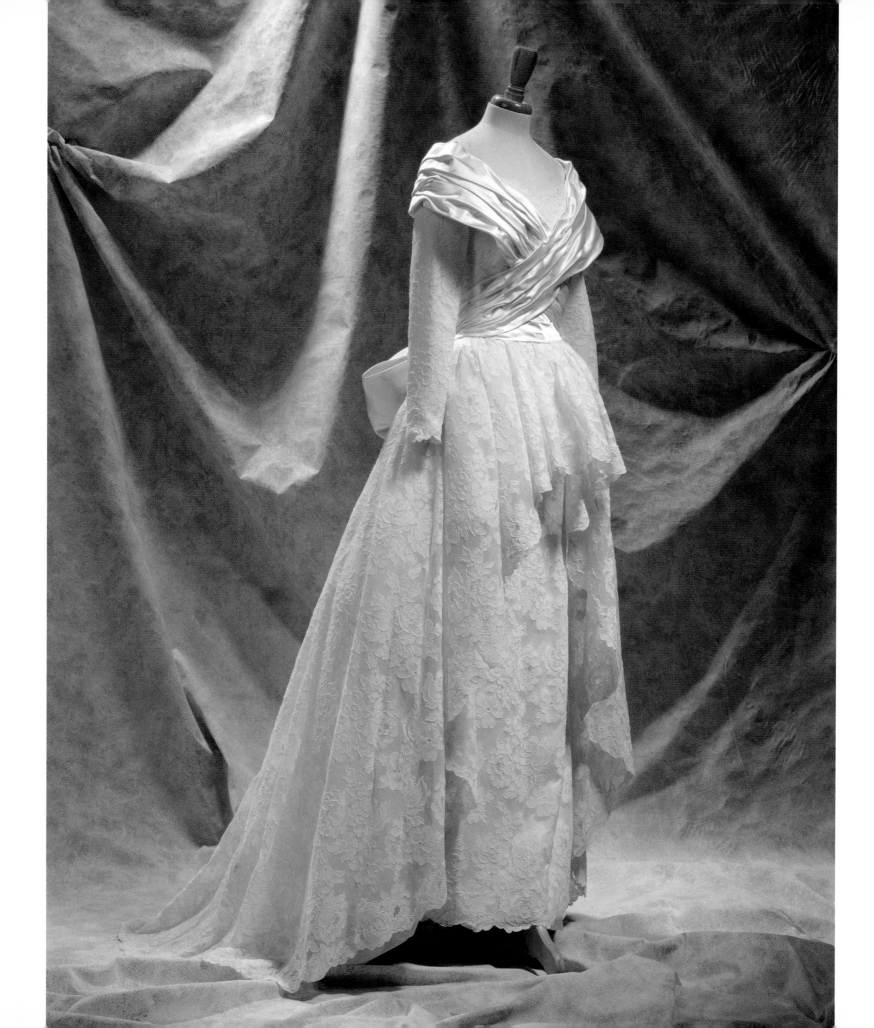

THE MARRIAGE PARTY WENT ACROSS THE GRAVEYARD

TO THE WALL, MOUNTED IT BY THE LITTLE STEPS, AND DESCENDED.

OH A VAIN WHITE PEACOCK OF A BRIDE PERCHING HERSELF

ON TOP OF THE WALL AND GIVING HER HAND

TO THE BRIDEGROOM ON THE OTHER SIDE,

TO BE HELPED DOWN! THE VANITY OF HER WHITE, SLIM,

DAINTILY-STEPPING FEET, AND HER ARCHED NECK.

AND THE REGAL IMPUDENCE WITH WHICH SHE SEEMED

TO DISMISS THEM ALL, THE OTHERS, PARENTS AND WEDDING

GUESTS, AS SHE WENT WITH HER YOUNG HUSBAND.

D. H. Lawrence, THE RAINBOW (1915).

Victor Edelstein wedding dress, 1987.

My Mayday Bride

My Mayday bride,

My Mayday bride!

The buttercups' petals are open wide,

They bow to the sun in festive pride,

While the May grass swings its lances.

And flower candles by the thousands

Light the hall of the earth with gold,

Where you will lead the dances.

My Mayday bride,

My Mayday bride!

I am the buttercup's heart so wide,

I wear the garment of passion's pride

To partner you on your way, love.

And born of my sorrow's crystal dew

Are the flowers of song I wove for you

To bind on your brow today, my love.

VILHELM KRAG (1871–1933).

Victor Edelstein wedding dress, 1987.

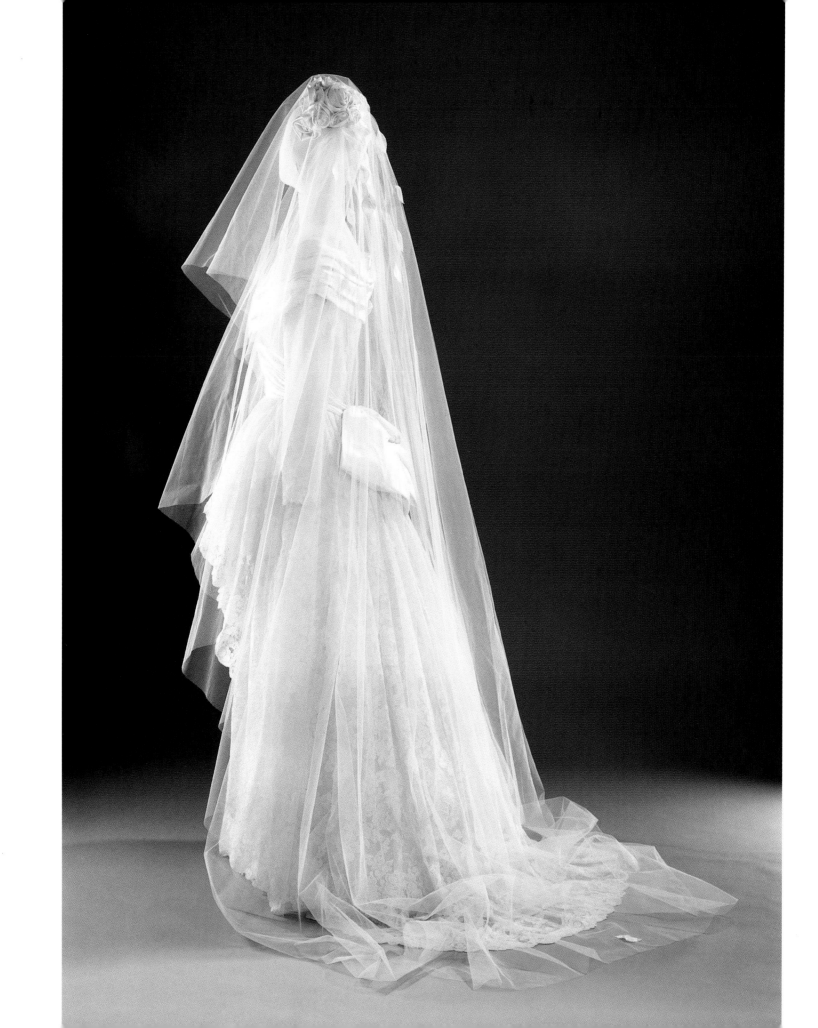

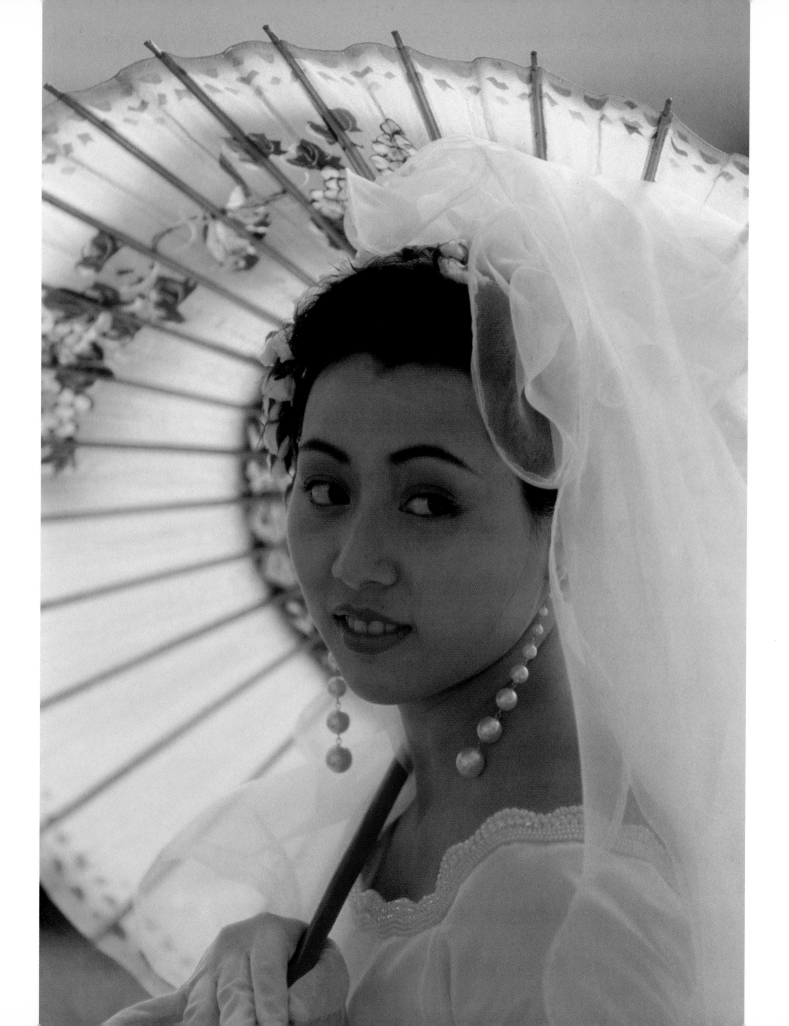

The day I got him to propose to me . . .

I asked him with my eyes to ask again yes and then he asked

me would I yes to say yes my mountain flower and first I put

my arms around him yes and drew him down to me

. . . and his heart was going like mad and yes I said yes I will Yes.

JAMES JOYCE, *ULYSSES* (1922).

THE GREATER THE AREA OF UNCONSCIOUSNESS,

THE LESS IS MARRIAGE A MATTER OF FREE CHOICE,

AS IS SHOWN SUBJECTIVELY IN THE FATAL COMPULSION

ONE FEELS SO ACUTELY WHEN ONE IS IN LOVE.

Carl Gustav Jung, "Marriage as a Psychological Relationship," 1925.

A Chinese bride, 1991.

Marriage Song

You are more beautiful than light
That trips across a waking lawn,
To pour on jonquils washed with night
The hoarded prism of the dawn.

You are more lovely than the ray
That trembles on a new-born leaf
When dusk steals on the drowsy day
To gloat on beauty like a thief.

Since that white flaming speechless hour
When vast and overshadowed wings
Housed you with Joy itself, the Power
To whom its own perfection sings,

O bride of uncreated light,
Caressed by love's infinity,
There dwells no dark in any night,
No danger lurks on land or sea.

WILLIAM THOMAS WALSH (1891–1949).

A young Indian bride in traditional adornment, 1991.

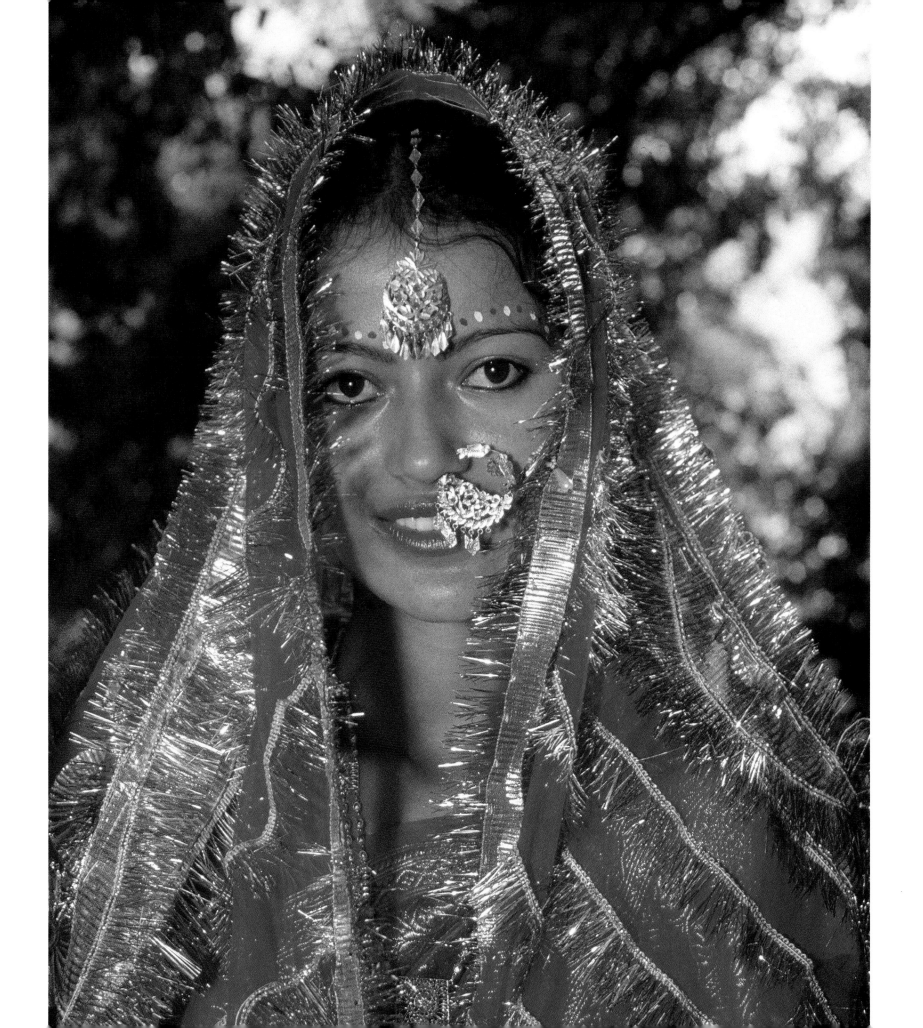

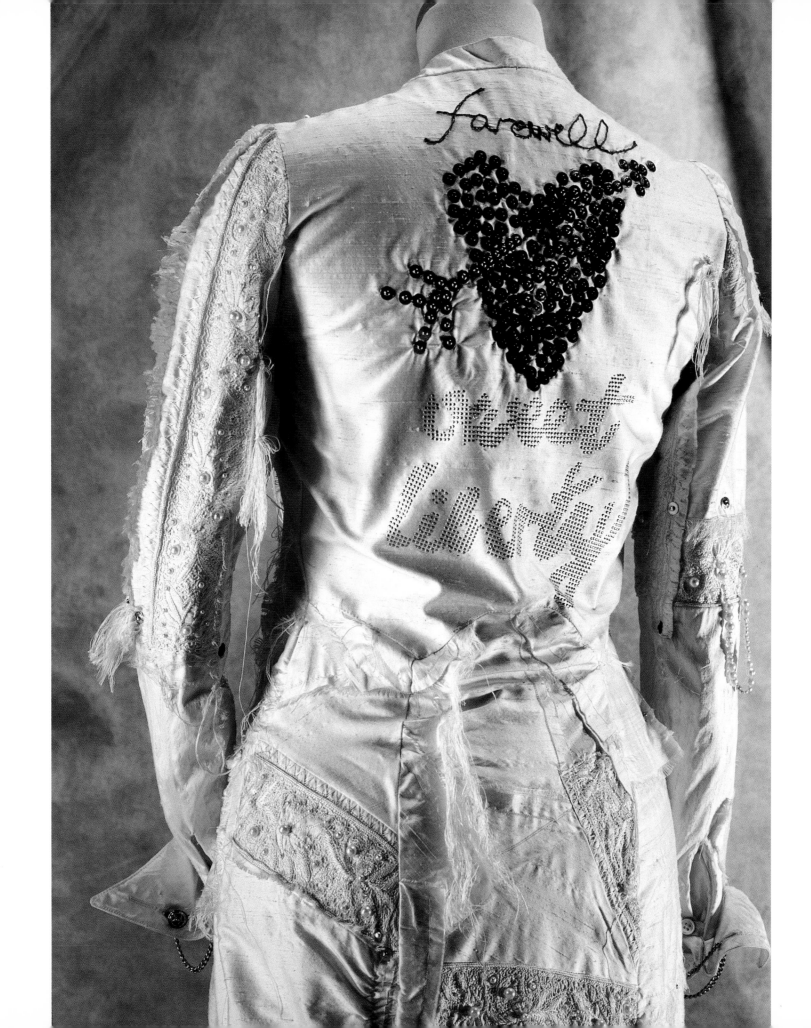

BRIDE

JOY COMES TO US AS A BRIDE

THE FIRST RAINS BURST INTO BLOOM

NIGHTINGALES STRIKE UP A DANCE IN OUR NEIGHBORHOOD

ELEGANT WATER NYMPHS BRING SONGS

THOUGHTS TURN INTO GOLD

AND GOLD ALL CONVERSATION

POETS AND GIRLS

LEARN KISSES BY HEART

SOMEONE ARRIVES AT THE FESTIVAL OUT OF BREATH

IT IS TIME WITH HIS FLUTE.

George Sarandaris (1907–41).

Detail of a Joe Casely Hayford wedding dress, c. 1993.

THE BRIDE

My CIRCLE IS NARROW AND THE RING OF MY THOUGHTS

GOES ROUND MY FINGER.

THERE LIES SOMETHING WARM AT THE BASE

OF ALL STRANGENESS AROUND ME,

LIKE THE VAGUE SCENT IN THE WATER LILY'S CUP,

THOUSANDS OF APPLES HANG IN MY FATHER'S GARDEN,

ROUND AND COMPLETED IN THEMSELVES —

MY UNCERTAIN LIFE TURNED OUT THIS WAY TOO,

SHAPED, ROUNDED, BULGING AND SMOOTH AND — SIMPLE.

NARROW IS MY CIRCLE AND THE RING OF MY THOUGHTS

GOES ROUND MY FINGER.

Edith Sodergran (1892–1923).

Miss Piggy, of Muppet fame, displayed in a lavender wedding gown at the Strong Museum, Rochester, New York, c. 1996.

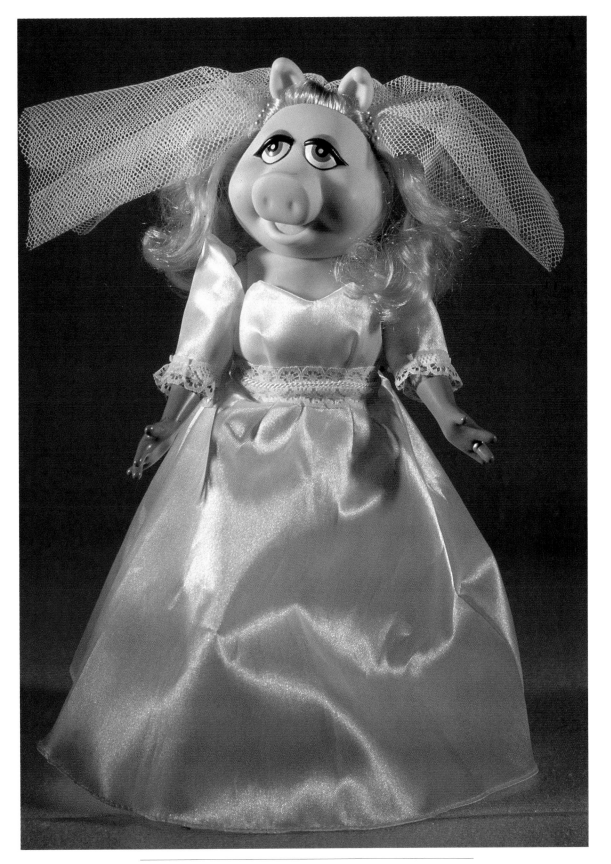

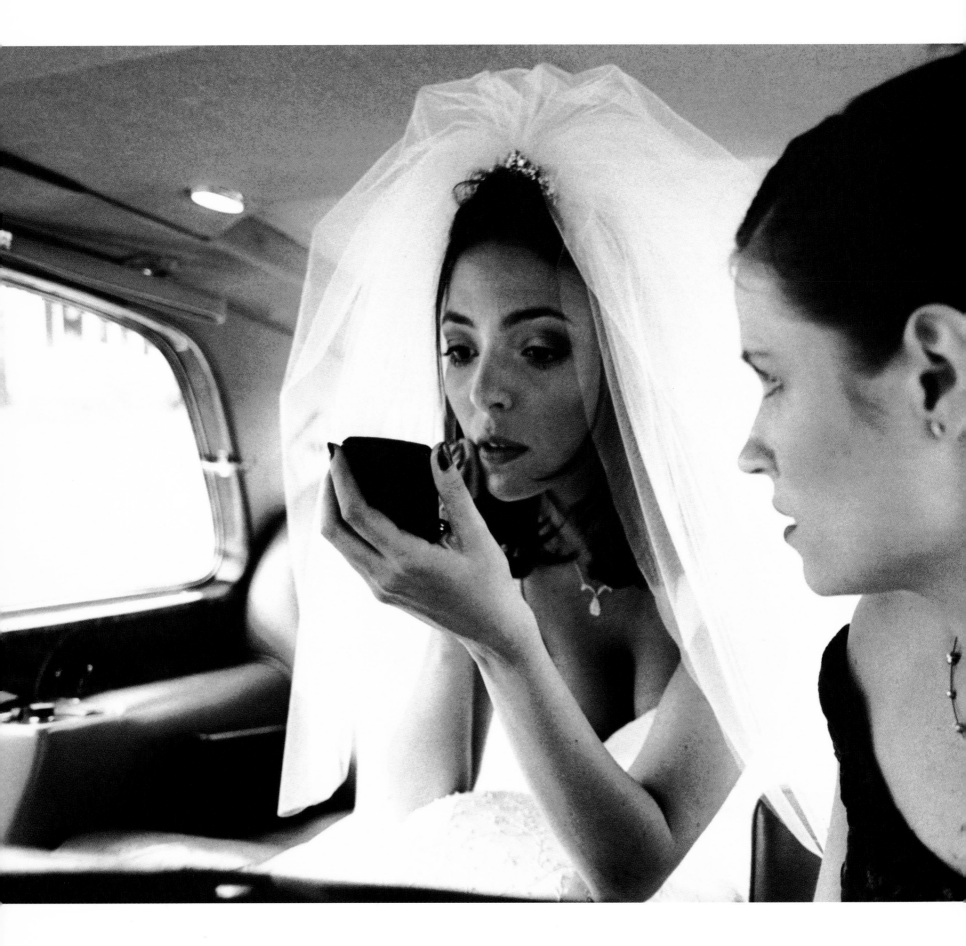

THE LOVE WE GIVE AWAY IS THE ONLY LOVE WE KEEP.

Elbert Hubbard, THE NOTE BOOK *(1927).*

Love should be a tree whose roots are deep in the earth,

but whose branches extend into heaven.

BERTRAND RUSSELL,
"SEX AND INDIVIDUAL WELL-BEING," *MARRIAGE AND MORALS* (1929).

Get me to the church on time – a bride applies the final touches to her makeup in the taxi to the church, 1990s.

Then Almitra spoke again and said, And what of Marriage, master?

And he answered saying:

You were born together, and together you shall be for evermore.

You shall be together when the white wings of death scatter your days

Aye, you shall be together even in the silent memory of God.

But let there be space in your togetherness.

And let the winds of the heavens dance between you.

Love one another, but make not a bond of love:

Let it rather be a moving sea between the shores of your souls.

Fill each other's cup but drink not from one cup.

Give one another of your bread but eat not from the same loaf.

Sing and dance together and be joyous, but let each one of you be alone,

Even as the strings of a lute are alone though they quiver with the same music.

Give your hearts, but not into each other's keeping.

For only the hand of Life can contain your hearts.

And stand together yet not too near together:

For the pillars of the temple stand apart,

And the oak tree and the cypress grow not in each other's shadow.

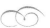

KAHLIL GIBRAN, *THE PROPHET* (1926).

A Hindu wedding ceremony, 1980s.

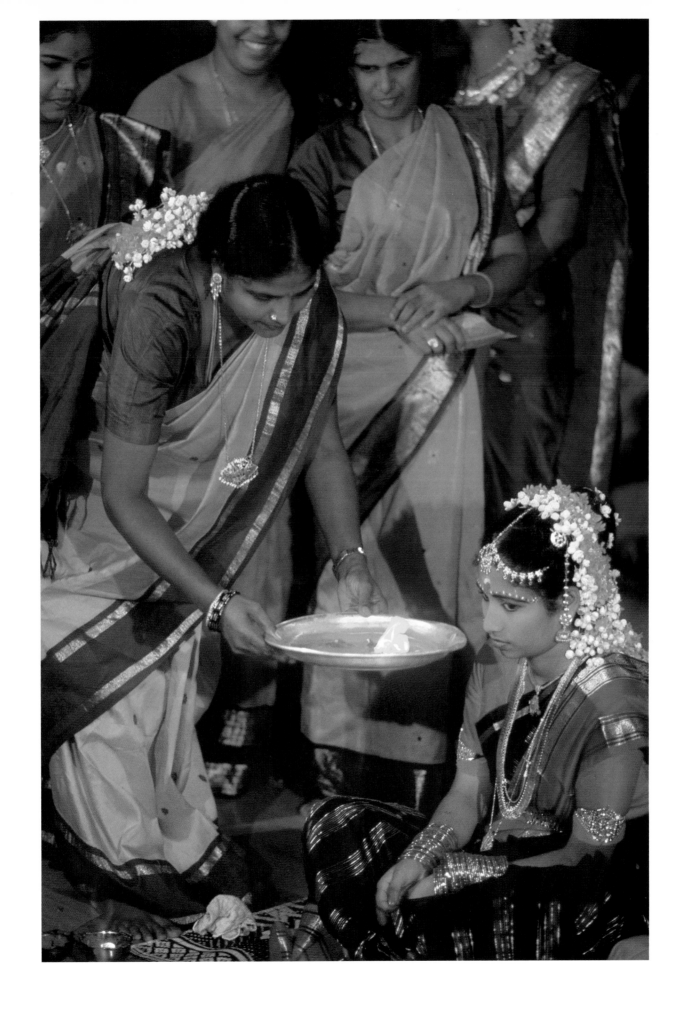

...Caroline **lovelier** than he had ever seen her,

floating all softly down through the past

and forward to the future by the sunlit door.

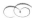

F. SCOTT FITZGERALD, *THE BRIDAL PARTY*, 1930.

WHEN YOU LOVE SOMEONE

ALL YOUR SAVED-UP WISHES START COMING OUT.

Elizabeth Bowen, THE DEATH OF THE HEART *(1938).*

Oyster-pink duchesse-satin wedding dress by Catherine Rayner, 1997.

This **bridal** day with gold I will enchain,

And wear its hours like rubies on my heart,

That you and I from Love may never part

Wile still these jeweled monuments remain.

These monuments, wrought out of hours, contain

The wound inflicted on me by Love's dart,

That stung with such intolerable smart,

Until to-day we vanquished Time and Pain.

Bridal Day

And now I wear this crimson diadem

Where late my heart I did incarnadine

With open wounds in passionate array,

Unhealed until your eyes looked down at them,

And crystallized their sanguine drops to shine

In captured moments of our bridal day.

COMPTON MACKENZIE (1883–1972).

A Sumbawese bride framed by mangoes, symbolizing fertility, 1990s.

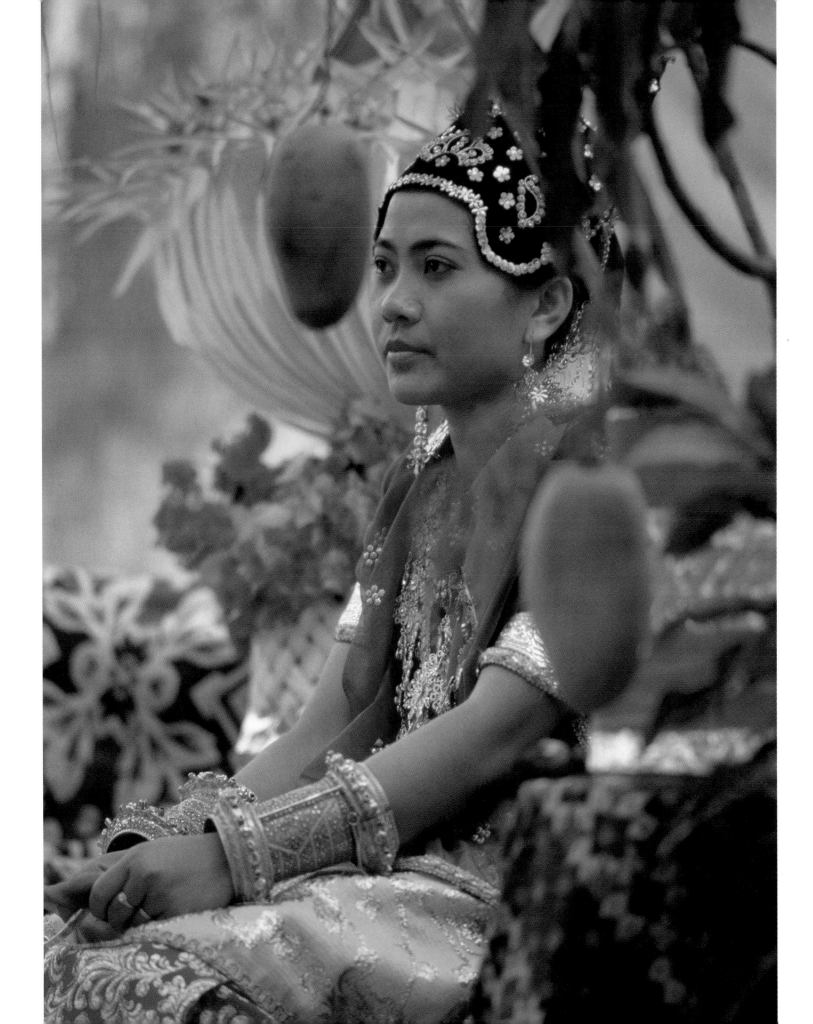

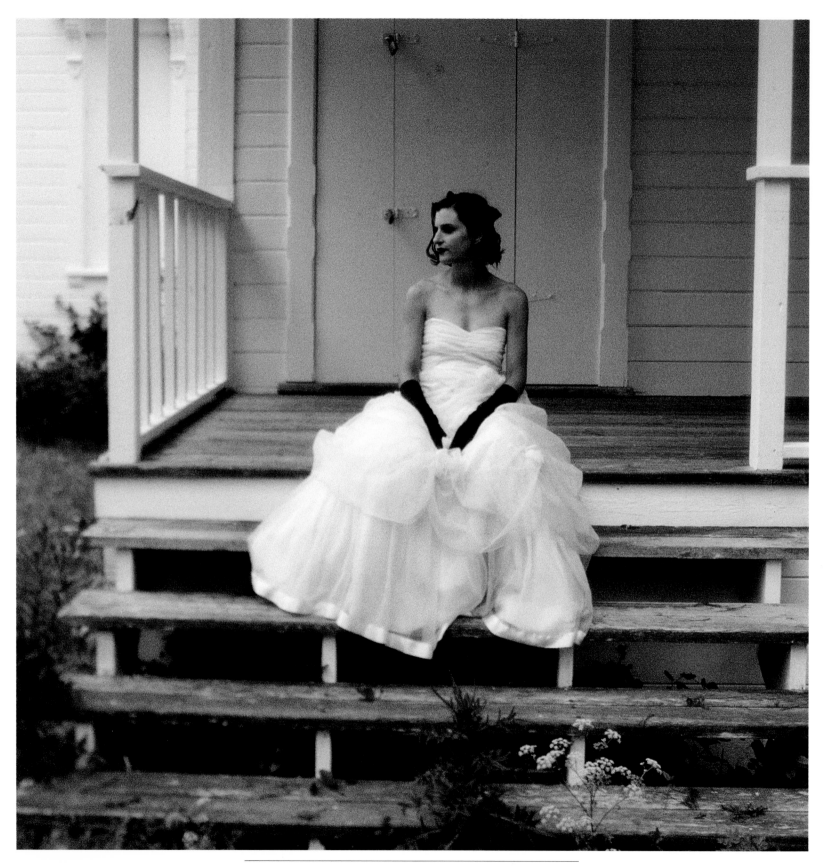

The supreme and overmastering desire of any two humans

who are in love with one another is to be together and alone,

in shared and mutual solitude.

That (in much) is what weddings are for.

It is attained and safeguarded in marriage.

How well and happily then should it be spoken of,

how profound should be its appeal to our common humanity.

WALTER DE LA MARE (1873–1956).

My MOST BRILLIANT ACHIEVEMENT

WAS MY ABILITY TO BE ABLE TO PERSUADE MY WIFE TO MARRY ME.

Winston Churchill (1874–1965).

An American bride pictured sitting on porch steps, 2000.

Bibliography and Acknowledgments

The International Thesaurus of Quotations, Penguin Books, Harmondsworth, 1976.

Avril Lansdell, *Wedding Fashions, 1860–1980*, Shire Publications Ltd., Princes Risborough, 1987.

Gertrud Lehnert, *Fashion*, Laurence King Publishing, London, 1998.

Anthony Lejeune (Ed.), *The Concise Dictionary of Foreign Quotations*, Stacy London, London, 1998.

Anne McIntyre, *Flower Power*, Henry Holt and Company, Inc., New York, 1996.

Joy McKenzie, *The Best in Bridalwear Design*, B. T. Batsford Ltd., London, 1998.

Bel Mooney (Ed.), *The Vintage Book of Marriage*, Vintage, London, 2000.

The Oxford Dictionary of Quotations, Oxford University Press, 1996.

David Pickering, *Dictionary of Superstitions*, Cassell, London, 1995.

F. Scott Fitzgerald, *The Lost Decade and Other Stories*, Penguin Books, Harmondsworth, 1968.

Lena Tabori & Natasha Tabori Fried (Eds.), *The Little Big Book of Love*, Welcome Enterprises, Inc., New York, 1999.

Treasury of Wedding Poems, Quotations, and Short Stories, Hippocrene Books, Inc., New York, 1998.

Weddings, Brockhampton Press, London, 1996.

Jack Zipes (Translator), *The Complete Fairy Tales of the Brothers Grimm*, Bantam Books, New York, 1992

∞

The publisher wishes to thank the following for kindly providing the images in this book:

© Annabel Williams/CORBIS for front cover;

© Trinette Reed/CORBIS for pages 2 and 126;

Hulton Getty Picture Collection for pages 5, 9, 13, 15, 23, 27, 34, 37, 52, 54, 57, 58, 60, 62, 65, 66, 69, 70, 76, 83, 86, 90 and 103;

© Francis G Mayer/CORBIS for page 6;

© V&A Picture Library for pages 10, 38, 41, 109, 114 and 122, supplied courtesy of the Trustees of the V&A;

© Bettmann/CORBIS for pages 16, 24, 49, 89, 93 and 95;

© Archivo Iconografico, S.A./CORBIS for pages 19, 20 and 28;

© Christie's Images/CORBIS for pages 30;

© V&A Picture Library for page 33, supplied courtesy of the Trustees of the V&A/Paul Robins;

© CORBIS for page 42;

Photograph on page 44 supplied courtesy of the author;

© Hulton-Deutsch Collection/CORBIS for pages 46, 50, 72, 75, 80 and 96;

© V&A Picture Library for pages 79, 84 and 106, supplied courtesy of the Trustees of the V&A/Daniel McGrath;

© Philip Gould/CORBIS for page 99;

© Charles & Josette Lenars/CORBIS for page 100;

© Quadrillion/CORBIS for page 105;

© James Marshall/CORBIS for page 110;

© Janet Wishnetsky/CORBIS for page 113;

© Richard T Nowitz/CORBIS for page 117;

© Rob Goldman/CORBIS for page 118;

© Nik Wheeler/CORBIS for page 121;

© Lindsay Hebberd/CORBIS for page 125.